\mathcal{A} History
OF THE
Greenwich
WATERFRONT

A *History*
OF THE
Greenwich
WATERFRONT

Tod's Point, Great Captain Island
and the Greenwich Shoreline

Karen Jewell

Charleston · London

THE
History
PRESS

Published by The History Press
Charleston, SC 29403
www.historypress.net

First published 2011

Manufactured in the United States

ISBN 978.1.60949.203.8

Library of Congress Cataloging-in-Publication Data

Jewell, Karen.
A history of the Greenwich waterfront : Tod's Point, Great Captain Island and the
Greenwich shoreline / Karen Jewell.
p. cm.
Includes bibliographical references.
ISBN 978-1-60949-203-8
1. Greenwich (Conn.)--History. 2. Waterfronts--Connecticut--Greenwich--History. I. Title.
F104.G8J48 2011
974.6'9--dc22
2011013397

CONTENTS

ACKNOWLEDGEMENTS

As with most literary projects, it becomes quite clear early on in the process that the author's ability (or quite often, luck) in acquiring the proper resources and support system is of the utmost importance to successfully completing the task at hand. When I first began my research for *A History of the Greenwich Waterfront*, I could not have ever imagined just how fortunate I would be in that respect. As much as I would love to be able to thank everyone who contributed in even the smallest of ways, I would especially like to acknowledge a few individuals who truly made this particular project exceptionally enjoyable and interesting. In no particular order, I would like to offer my utmost gratitude and sincere appreciation to Jeff Freidag, for steering me in the right direction when it came to information about the Riverside Yacht Club; Nancy Standard, for being one of those "right directions" and generously taking the time to go over the many fabulous vintage photographs in the Riverside Yacht Club archives; Mary Curcio, Carl White and Cathy Ogden of the Greenwich Library, for each of their invaluable contributions of time, images and information that were beyond the call of duty; Regina Pitaro, for helping out with a few facts about the Belle Haven Club history; Shelia Graves, for providing unique insight in regards to the Indian Harbor Yacht Club; Ron and Nancy Borge, for kindly sharing some of their personal family photos and stories about the celebrated Victor Borge; and my mother and father, who continue to encourage and support all of my endeavors with the utmost enthusiasm.

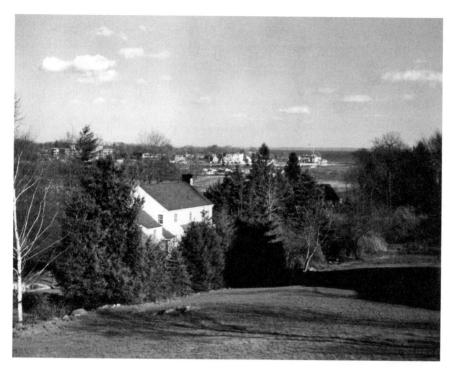

Greenwich Harbor. *Courtesy of the Greenwich Library.*

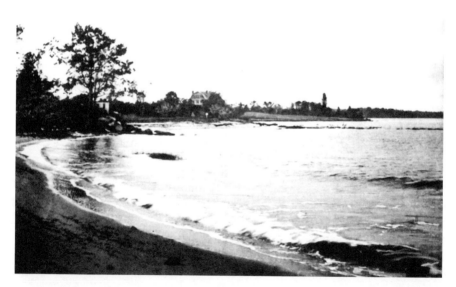

Sandy Point Beach. *Courtesy of the Greenwich Library.*

Introduction

As the subject of the third book in a trilogy about the history of the southern shoreline of Connecticut, the Greenwich waterfront easily proved to offer as much intriguing and fascinating information as the previous two projects. Having fallen in love more than twenty-five years ago with this pristine coastline, I was not surprised. As it was a natural choice to round out the three-book project with the captivating history of Greenwich, I was more than excited to get started on the research. With the help of many who clearly hold the same passion as I for the local shorefront, the task continued to get even better with each step forward.

It would be easy for me to go on and on about the many unforgettable and enlightening moments that occurred during the process of putting together *A History of the Greenwich Waterfront*, but instead, I offer you the chance to discover and experience the fabulous voyage for yourself. So please sit back, put your feet up and enjoy a nautical passage back in time to a bygone era that will forever hold a special place in the history of maritime New England.

SETTING THE STAGE

Geographically, the town of Greenwich is situated in the southwest corner of Connecticut, with Westchester County, New York, to the west and Stamford to the east. To the south lies Long Island Sound. During its early years, Greenwich settlers described the area as being "hilly and rocky, and the soil is very fertile."

Originally, there were four Native American tribes that claimed the southern section of Greenwich as their home. They included the tribes of Asamuck (in Sound Beach), Patomuck (also in Sound Beach), Petuquapaen (in Cos Cob) and Miossehassaky (on the southern border). It is believed that the Petuquapaen were the most dominant, boasting approximately five hundred warriors.

Other tribes living in Greenwich included the Siwanoys, located on the west side of the Byram River, and the Weeckquesqueecks, located to the northwest of the Siwanoys. Both the Siwanoy and Weeckquesqueeck tribes were members of the larger Mohegan tribe, a group that covered most of Quinnehtukqut, or Connecticut.

The original ten towns in Connecticut were established between 1633 and 1640, with Greenwich being the tenth. The others were Windsor, Wethersfield, Hartford, Saybrook, New Haven, Milford, Fairfield, Stratford and Guilford. These communities were all a result of the migration of settlers who had first occupied the Massachusetts Bay Colony and the Boston area.

The Patricks and the Feakes were the founding families of Greenwich, officially acquiring the rights to the land in 1640 from the local Native

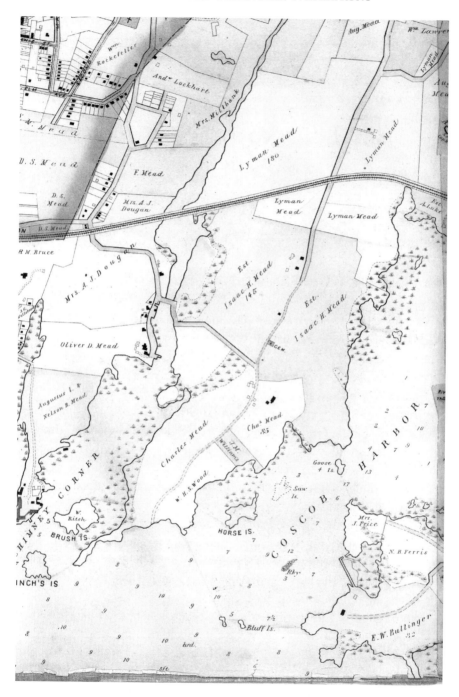

An early map of Greenwich. *Courtesy of the Greenwich Library.*

Americans, who at that point were dwindling in population as an end product of the Pequot Wars and the smallpox epidemic of 1634. Before them, it is thought that the Norsemen occupied the area from about 1100. This theory comes from the discovery of mooring holes on Bluff Island off Greenwich Point. Presumably, the Norsemen inserted poles here to tie their vessels; this was a trademark plan of theirs in order to make a quick getaway should the local natives suddenly decide to express displeasure about their presence.

It is believed that a pioneer by the name of Jeffrey Ferris was responsible for giving Greenwich its name, in honor of his hometown of Greenwich, England. Before Patrick and Feake arrived, it appears that the 1640 deed granted a previous claim to Ferris by Keofferam, the son of the Indian chief of the Siwanoy tribe Mayn Mianos (or Myanos).

The local natives sold the land between the Asamuck (the stream through Binney Park) and Patamuck (the stream on the boundary between Stamford and Greenwich) to Captain Daniel Patrick and Robert Feake for twenty-five English coats on July 18, 1640. Additionally, Elizabeth Fones Feake (wife of Robert) secured Monakewaygo (Greenwich Point) as her own purchase. After Mrs. Feake's acquisition, the area that we now know as Tod's Point was referred to as Elizabeth's Neck for several years.

That historical deed, as found in the town records according to *Ye Historie of Ye Town of Greenwich* by Spencer P. Mead, reads as follows:

Wee Amogerone and Owenoke, Sachems of Asamuck, and Rammatthone, Nawhorone, Sachems of Patomuck, have sould unto Robert Feaks and Daniell Patricke all theire rights and interests in all ye severall lands betwene Asamuck River and Patomuck, which Patomuck is a littel river which divideth ye bounds betwene Capt. Turner's Perchase and this, except ye neck by ye indians called Monakewego, by us Elizabeth Neck, which neck is ye peticaler perchase of Elizabeth Feaks, ye sd Robt Feaks his wife, to be hers and her heaires or assigns, forever, or else to be at ye disposal of ye aforementioned purchasers forever, to them and theire heaires, executors or assigns, and theye to enjoy all rivers, Islands, and ye severall naturall adjuncts of all ye forementioned places, neigther shall ye indians fish within a mille of aney english ware, nor invite nor permit aney other indians to sett down in ye forementioned lands; in consideration of which lands ye forementioned purchasers are to give unto ye above named sachems twentie five coates, whereof theye have reserved eleven in part payment; to witness all which, theye have hereunto sett theire hands this 18 July 1640.

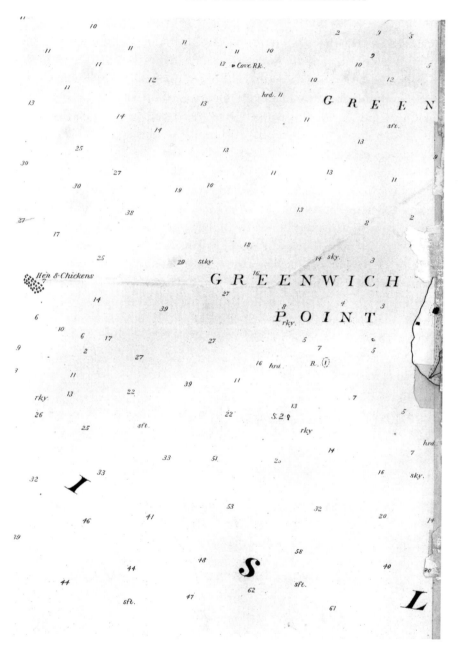

An early map of Greenwich Point. *Courtesy of the Greenwich Library.*

Signature marks of the witnesses included Robert A. Heusted (delivered by his messenger Andrew), Rasobibitt, Saponas, Whonehorn, Akeroque, Pauonohas and Powiatoh. In closing, the deed stated, "Keofferam hath sould his right in ye above sd to Jeffere Ferris. Witness: Richard Williams, Angell Heusted."

Almost immediately after signing the historical agreement, the new owners set forth to stake their claim. With the experience of having settled a number of territories previously, this task was somewhat easy for both Patrick and Feake.

However, there was one major obstacle that came about for the new settlement of Greenwich, which occurred shortly after the deed for the neighboring community of Stamford was signed in 1641. At that point in time, there was confusion as to where the official town lines began and ended. After much consideration and deliberation, on November 2, 1641, an agreement was made. According to Mead's *Ye Historie of Ye Town of Greenwich*, it read as follows:

> *Wee, the underwritten, mutually agreed that the dividing line betwene both our Plantations of Greenwich and Wetherfield Men's Plantation shall begin at Patommog Brook, where the path at present cuts, and run on in a straight line to ye west end of a line drawne from ye sides of Wetherfield Men's Plantation River, which runs by theire towne plot, to bee drawne on a due west point towards Greenwich bounds, a neat mile, and from ye west end of ye sd line to run due north up into ye contrie, about twenty miles. These lines to run on ye meridian compass. Nether will aney of us or shall aney for us object against this agreement upon ye account of ye Indians; although we shall at aney time hereafter conclude a mistake in respect of what each one bought, yett this to stand unalterable, without a mutual consent on both sides. To Testifie which, wee each for our townes have sett to our hands this 2nd Nov. 1641.*
>
> > *Daniell Patrick, Andrew Warde,*
> > *Robt. Fekes, Robert Coe,*
> > *Richard Gildersleve.*

Sadly, both Captain Patrick and Robert Feake passed away within a few years of acquiring their new land. Elizabeth Feake eventually remarried to a man by the name of William Hallett.

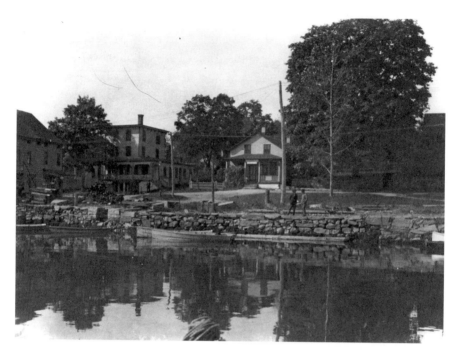

The Lower Landing in Cos Cob. *Courtesy of the Greenwich Library.*

Once officially established, Greenwich began to grow and flourish as a seaside community during the mid-1600s. By the time the late 1800s arrived, the town was beginning to be recognized by a more global audience. In an article published in *A Gazetteer of the States of Connecticut and Rhode-Island* in 1819, Greenwich was featured as a "maritime post township" that, although "hilly and broken," offered fertile soil and many opportunities for fishermen and other commerce along Long Island Sound.

At that time, the maritime industry in Greenwich was divided into three sections: the "Upper," the "Lower" and the "Bushes." With its proximity to New York and its thriving business district, Greenwich quickly became a major source of trade. With the combination of naturally fertile soil that supplied local farmers with ideal harvesting conditions and the easy accessibility to the water and shipping as a means of transportation, residents of Greenwich soon recognized the opportunity for great financial gain if they wisely took advantage of their unique circumstances. Dockside warehouses, gristmills, ship chandleries and sail lofts are just a sample of the businesses that began to spring up along the waterfront.

Greenwich Harbor. *Courtesy of the Greenwich Library.*

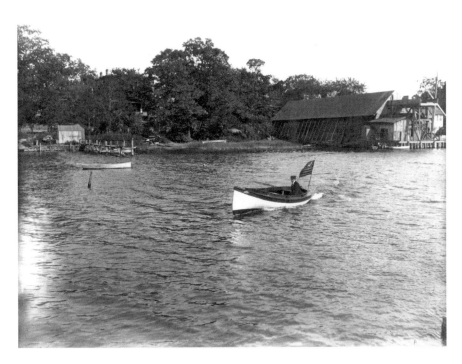

A runabout cruising in Greenwich Harbor. *Courtesy of the Greenwich Library.*

During the ensuing years, Greenwich would prosper in many respects, but it would also make a name for itself as an icon in an international, upper-echelon society.

Join us as we follow that journey in its evolution, learning about the local shoreline history in a way never experienced before.

The Islands and
the Lighthouse

G reenwich is a coastal community located directly along Long Island
Sound that boasts amazing and unrivalled water views, as well as an
intriguing selection of unique seascapes.

Taking a closer look at Long Island Sound will reveal its impressive
dimensions of approximately 110 miles in length, 23 miles in width and some
787,000 acres overall. With that in mind, it is quite remarkable that Long
Island Sound actually began as a small river tens of millions of years ago.

During its development, the sound has assumed the roles of valley, glacier,
lake and, ultimately, the grand estuary it is today. Over the years, scientists have
used submarines, sonar devices, drills and remote-controlled vehicles to try and
uncover the exact history of the sound. Their discoveries have been astonishing.

Underwater ridges, shoreline cliffs created from clay, embedded shells of
sea life that is now long gone and the unmistakable handprints of sheets of
ice that reached heights of close to one thousand feet are just a few of the
intriguing finds that have been uncovered.

When the last glacier receded nearly twenty-three thousand years ago, it left
in its wake a remarkable series of lakes and harbor inlets from Massachusetts
to New York. These lakes were collectively known as the Glacial Lake
Connecticut. Scientists believe that about three thousand years after the birth
of Lake Connecticut, erosion caused the water to slowly drain through a
moraine ridge near Fishers Island, New York. For a brief period, parts of the
valley reappeared, but these areas were soon washed over as the rising sea
levels from the Atlantic Ocean began to pass through the same opening, in the

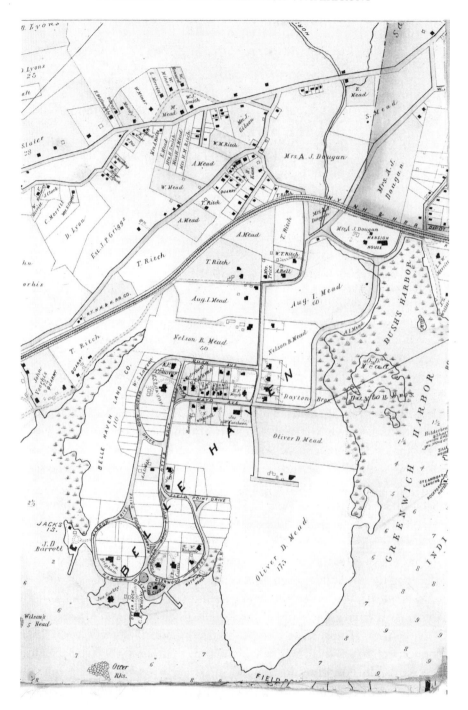

An early map of Greenwich Harbor. *Courtesy of Rhoda Jenkins, from the collection of the Greenwich Library Oral History Project.*

Tod's Point, Great Captain Island and the Greenwich Shoreline

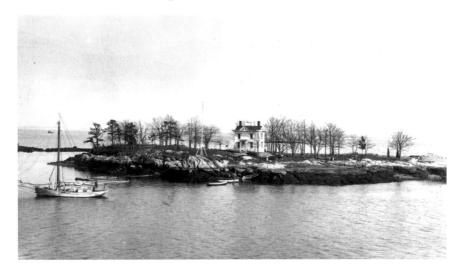

Finch Island. *Courtesy of the Greenwich Library.*

Swimming at Round Island. *Courtesy of the Greenwich Library.*

opposite direction. As a direct result of the effects of the glacial age, Greenwich is now host to an impressive and interesting collection of islands. Among them are Jack Island, Rich (or Ritch) Island, Farwell's Island, Shore Island, Bower's Island, Calf (or Calves) Island, Bluff Island, Tweed Island, Great Captain

Island, Little Captain Island, Wee Captain Island, Pelican Island, Greenwich Island, Pipen Island, Goose Island, Diving Island, Cove Island, Horse Island, Brush Island, Finch Island and Shell Island. (As a side bar, it should be noted that several of the islands have been called a variety of names throughout the years. For instance, Shell Island has also been referred to as Huss's Island and Elmer's Island.) Cormorant Reef and the rock formation known as Hens and Chickens are additional remnants of the glacial influence.

Jack Island, originally named Fisherman Jack's Island, was purchased by John D. Barrett Sr. His intention was to build on it, although most people thought that he was crazy because the island was so small and was only considered a "real" island at high tide. At low tide, it was clearly connected to the mainland, albeit by mud. In an attempt to make the island larger and to create a navigable channel for his boat, Barrett dredged out most of the mud with the help of huge barges. One acre of the island today is made up of muck from the dredging project. Once workers finished relocating the soft soil, a wall was constructed to help support the newly created land design.

Rich (or Ritch) Island was once the home to Captain Blanchard Gardner. Gardner had been a sailor for over fifty years and had navigated waters all over the world. Cap'n Gardner, as he was respectfully called, enjoyed telling stories about his travels to China and other foreign ports to the delight of everyone who had the chance to listen to him.

Calves Island has the distinct reputation of harboring a buried treasure, presumably left there by a seafaring pirate. Approximately forty acres overall, Calves Island features a beautiful crescent beach on its south side.

Four of the islands situated between the Byram and Belle Haven shorelines are collectively known as Brothers Island. These include Rich (Ritch) Island, Farwell's (or Marx's) Island, Game Cock and Shore Island. They are all connected by a causeway.

Shell Island is 5.23 acres in size and is located off the Byram shore. It boasts sandy beaches, impressive rock formations and thick woodlands. Horseshoe crabs and shorebirds such as the snowy egret are regular visitors to the isle. Shell Island was named because of the plentiful and uniquely beautiful gold and pink shells found on its shore. Prior to that, it was known as Little Calves Island from the days when cows used to cross the sandbar at low tide to eat grass on the larger Calves Island.

August Otto Eimer, president of Eimer and Amend at the time, purchased Shell Island for $40,000 in 1910 from Mary Huss, the widow of Colonel Henry Huss, a Civil War veteran.

Eimer and his family had lived nearby on shore during summer vacations, so they had many friends in Greenwich and loved the area. When Shell Island was put up for sale, Eimer was quick to make an offer.

The Eimers were well known for their exquisite dining tastes. The finest tablecloths, napkins and linens adorned every meal. The linens were never folded but instead were carefully suspended on bamboo poles to maintain their integrity. They were all embroidered with each month of the year written in German. The Eimers used Dresden china for serving, which typically is only seen in the finest museums. Chandeliers, decorative angels and fabulous glass breakfronts were also found throughout the house.

The Eimers had many employees who worked at their estate on Shell Island, including house staff, kitchen personnel, cleaning help, nurses, gardeners and serving staff. They were treated very well by the entire Eimer family and enjoyed good salaries, generous holiday bonuses and fabulous meals. In return, the staff held the Eimers in high esteem.

Their summer house on the mainland was known by all as the "bungalow" and was a prefab structure purchased from the Sears, Roebuck & Co. catalogue. Since its design did not quite fit in with the other architecture along the waterfront at the time, many of the neighbors were a bit unhappy with it.

There were approximately five buildings on Shell Island, some from when the Husses had lived there and others that were built by the Eimers for guests and family. There were also quite a few boathouses on the property. Many of the buildings were given names such as the White House (the largest on the island), the Red House, the Yellow Cottage and the Spray Cottage.

Mr. Eimer especially enjoyed the huge porch at the White House, often sitting out on moonlit summer evenings. He was once quoted as saying, "There would be a golden path right in that water if you could get off that porch and just walk in the water."

There was a beautiful, natural tidal pool on the island left by each high tide. It was a great place to catch "gillies," the little fish used to lure larger snappers. There was also an abundance of starfish, mussels, mackerel and scallops in the tidal pool after the tide went out. Beachgoers had to be careful not to come in contact with the jellyfish, but fortunately the water was so clear back then, they were easy to see. Visitors were able to enjoy great fishing opportunities from the handful of docks on the island.

Because of the popularity of rowboats, the Eimers designed a method that utilized a rope to secure the small vessels so that a pulley system could haul them on shore. Bumpers were placed along the docks to protect the

boats from getting scratches or dings. A boathouse located next to the docks was used for storing tackle lines and other boating and fishing equipment.

Family members and their guests enjoyed wading out into the water and catching clams with their toes. The muddy ground proved to be ideal for finding the little shelled creatures. With their buckets filled, the "fishermen" would head back to the island and set forth making homemade clam chowder, adding freshly picked carrots, tomatoes and onions to the already delectable seafood bisque.

Fishing, swimming, rowing, canoeing and sailing were favorite pastimes for all who visited the island during the summer season. The island was also a great spot to enjoy the regular nightly fireworks displayed just down the coastline at Playland in Rye, New York.

There is an intriguing story that has been told throughout the years about a houseboat of sorts that was anchored along the sandbar between Big Calves Island and Shell Island during the early 1900s. Since it never moved, yet saw great activity, it was presumed to be owned by a bootlegger. There was never any problem to speak of with the vessel or its owner, so everybody pretty much just left it alone.

A pagoda was built atop a huge rock on Shell Island along the beach that faced Belle Island. It was made of concrete and stood about three feet tall. At the time, there was a Japanese-style bridge that led to it. Apparently, Mr. Eimer had acquired an antique store overseas and thought that the pagoda, which was part of the inventory, would be a nice aesthetic addition to the ambiance of the island.

A small beach outside the Red House was known as the official "Shell Shore Clubhouse." The "dues" to belong to the Shell Shore Club were five dollars a season. At its peak, the club boasted 150 members. It used the money collected from the annual dues to pay Mrs. Rosie Steixner, the club cook, who was well known for her delicious and irresistible Steixner's stew.

Mrs. Rosie Steixner's stew was so popular, in fact, that the Eimers decided to name the island newspaper after it. The *Steixner Stew* was extremely well received by guests and visitors to Shell Island, and eventually Mr. Eimer decided to publish it in New York, where it also received outstanding reviews.

A sample of its charm is the paper's subtitle, which stated, "A Paper for People Who Wink." Topics included such attention-grabbers as the following, featured in the Saturday, November 29, 1924 edition: "Weather Forecast: A Hot Time Despite Prevailing Drought."

In one of the regular columns of the journal titled "Bright Sayings of the Children," Master August Eimer reflected on the aforementioned record-setting dry season, saying, "All summer I begged Paul Murray to stop singing 'It Ain't Goin' to Rain No More.'"

Another column simply titled "Etiquette" provided insightful advice from Mrs. Van Rensselaer. A sample query read as follows: "Dear Mrs. Vanderfool: My brother Gus eats his soup with a loud, gurgling noise, accompanied by whistles and smacking of lips. What shall I do to cure him?"

The answer was profound: "Tell him to use a spoon."

As eluded to previously, the premise of the newspaper was to be fun, humorous and entertaining. Clearly, the "publishers" were successful at achieving their goal.

Shell Island was so unique that it even had its own currency, called "Shell Island Legal Tender." It was issued by the "Shell Island Sand Bank" and often translated to payment in the form of mussel shells.

The island was always very well kept, with immaculately groomed lawns, beautiful flower gardens and a perfectly maintained tennis court. Everything was very clean.

There was an abundance of wonderful trees on the island, including cherry, Bing cherry, gingko, crab apple, peach, plum and a quince tree. The Eimers made their own jelly from the grapes and watermelon that grew in their gardens.

The formal garden was known as Mary's Garden. There were Concord grape arbors and plenty of wildflowers, wisteria and tiger lilies.

There was a first-class croquet court on the island, and even though it saw constant use, it was still able to boast grass that was "cut to perfection."

Presumably, the many dirt walking paths that were found around the island were originally made by the local natives who had lived there before.

The Eimers used to bring Neilsen's ice cream over from the mainland in huge canisters for everyone to enjoy. With homemade root beer to go along with it, the ice cream floats were the best that anyone could imagine. With events hosting 150 people at a time, that was a lot of root beer and ice cream!

As time went on, the sport of sailing became quite popular. The small sailboats of the dory class from the Riverside Yacht Club, the Seawanhaka Corinthian Yacht Club and other local clubs would regularly stay at Shell Island prior to a competition. The boats would anchor just off the beach the night before an event or were stored in the island clubhouse. Since they were small, they were easily accommodated.

Above the boathouse was "Aunt Elsa's" art studio. Aunt Elsa was a very talented, passionate artist who worked with oils and clay sculptures.

A tower was erected on the island in 1925 in memory of Gus Eimer, who was lost to a serious bout of pneumonia at the age of forty-one. Gus Eimer was the firstborn son of August and was to be the next in line to run the family business.

The architect for the tower was Charlie Calhoun, and the builder was a man by the name of Mr. Rowe. In addition to being a memorial to Gus Eimer, "The Tower" was also, in essence, intended to be a family museum.

Each floor of The Tower had a theme, such as Gus Eimer's years at Columbia University, a history of the chemical equipment created at the family's pharmaceutical company and Elsa's treasured artwork.

Vivian Weadon Riesbeck wrote about the unique structure, stating:

> *On that beautiful isle in the mystical sea, Where life is unlimited, wondrously free wings a soul who has conquered vast spaces apart; Yet dwells in the round tower close to your heart. And I'm sure that he sees from the mansions on high your pillar of love nobly facing the sky; And he's happy and praises rare gifts of the arts. Those towers of memory Carved in your hearts.*

The island was sold to a Mr. Silver in 1961 for approximately $50,000.

Today, Shell Island is run by the Greenwich Land Trust. However, for all those who remember the early days or have heard the stories passed down from generation to generation, the island will forever remain "a magic place."

Little Captain Island, located approximately two miles south of Greenwich Harbor, was once a vibrant and energetic sibling of Great Captain Island. Officially opened on May 27, 1911, the island (also known as Island Beach) was originally owned and developed by a private corporation that had purchased it with the intentions of making it a profit-making venture. The group invested a substantial amount of money into its plans to construct a carousel building, dance hall, restaurant, shooting gallery, booth games, fish tanks and bungalows. Old-style, kerosene-powered generators supplied lights and electricity, and drinking water was brought over in wooden barrels. The bungalows were provided with a five-gallon bottle of water a day. The island restaurant used rain water collected on the roof of the dance hall and stored in twenty-five-hundred- to three-thousand-gallon wooden tanks. Toilets were flushed with salt water, which

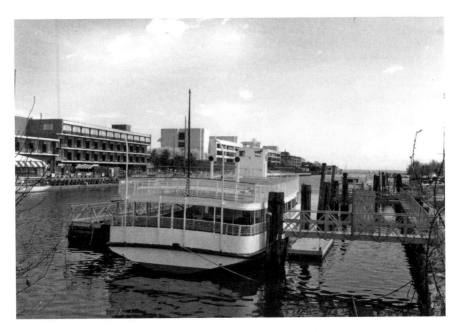

The *Island Beach* ferryboat during the 1980s. *Courtesy of the Greenwich Library Oral History Project.*

was pumped into a wooden tank located on top of the engine room. (This method was replaced in 1936 with a thousand-gallon water tank installed under the bathhouse along the boardwalk.)

Eventually, the Town of Greenwich took over during the late 1920s and early 1930s. At that point, moonlight sails, new bathhouses and live music featuring popular bands were added, and a ferryboat named the *Island Beach* began bringing passengers to and from the mainland. Initially, three boats brought park-goers from Port Chester, Stamford and Greenwich to this preferred waterside destination. The vessels were the *Dolaradora*, the *Gordon* and the *Bristol*, respectively. The town recruited two more vessels during the early 1930s, *Usona* and *Pal*, which ran until 1937.

The *Island Beach* was a wooden boat that berthed at the old Doran's Dock on Steamboat Road and sailed in Greenwich for nearly forty years. The first crew members of the vessel were Captain Sanford Mead and Engineer Winfield "Windy" Mills. When Captain Mead retired, he was replaced by Captain Clarence Palmer. Captain Palmer skippered the *Island Beach* from 1920 to 1923, before "Old" Captain Blanchard Gardner came on board from 1923 to 1937. At that point, the town purchased the *Indian Harbor*, a 256-person-capacity vessel, and Gardner's son, Jim, took over at the helm.

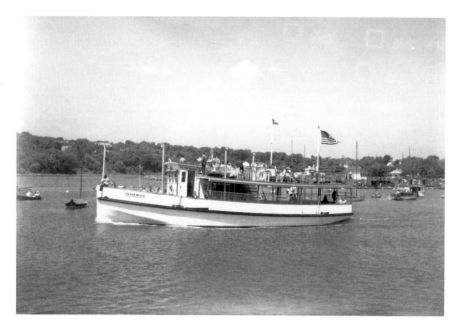

The *Island Beach* in 1947. *Courtesy of the Greenwich Library Oral History Project.*

After four decades of cruising in and around Greenwich Harbor, the *Island Beach* needed substantial repairs. Listed for sale, Guy Lombardo became the new owner and used it for the Jones Beach Theater in New York.

Back in the day, the fare to get to Island Beach was ten cents (during the week children were free). People used to regularly take the train from Manhattan to the boat, just to be able to get out and enjoy the excitement of the island.

To help with the high demand for vessels heading out to the island, a privately owned fifty-foot sailing yacht from Stamford named the *Massasoit* joined the ferry schedule. Other yacht owners wanted to get in on the profit, so they would wait just offshore until the other boats had departed and then offer their water taxi services to the beachgoers who were still on the dock.

The island was so busy at one point that a "resident-only" beach card was initiated.

Great Captain Island shared a similar story. However, due to a short summer season and the stateside effects of the World War on manpower and the economy, both islands struggled as moneymaking propositions.

Great Captain Island is one of the more well-recognized isles located off the Greenwich shoreline. Part of its fame has to do with the fact that it was home to the famous Great Captain Island Lighthouse.

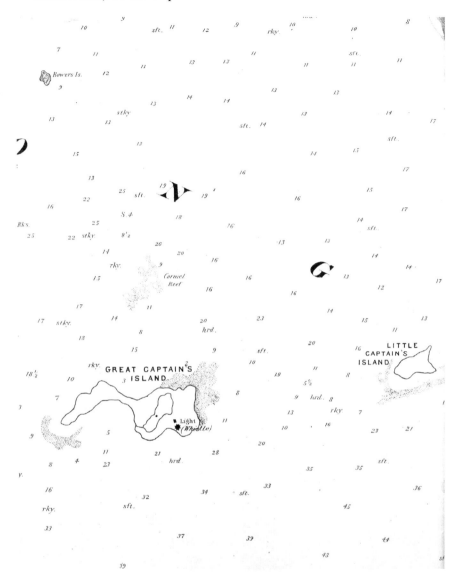

An early map of Great Captain's Island. *Courtesy of the Greenwich Library.*

Approximately seventeen acres overall and situated just over a mile from Byram, Great Captain Island boasts the bragging rights to being the southernmost point in Connecticut—and for that matter, all of New England.

It is believed that Great Captain Island, along with its neighboring islets known as Little Captain and Wee Captain, were named after one of the first settlers of Greenwich: Captain Daniel Patrick.

Interestingly, for nearly half a century, both Connecticut and New York claimed ownership of the island. However, during the beginning of the 1800s, it was declared to officially belong to the State of Connecticut.

Great Captain Island has hosted a variety of shorebirds for centuries, including egrets, osprey and blue herons, to name a few. Today, Great Captain Island continues to hold a spot on Connecticut's "important bird areas" list. (As a side note, Greenwich Point is also on the prestigious list.)

Great Captain Island once held the title of largest heron and egret rookery in Connecticut. The egrets especially enjoyed the plentiful cherry and black locust trees found throughout the southeast section of the island.

Situated in an ideal location on Long Island Sound, Great Captain Island was naturally the most appealing of all the surrounding isles when it came to the subject of erecting a lighthouse off the Greenwich shoreline. It was close enough to the shipping lanes, as well as the many dangerous rocks, shoals and ledges along the coast, to act as a productive navigational guide for passing vessels to get their bearings and to warn them of potential danger. It is for that reason that Congress approved $5,000 on March 3, 1829, for "a light house on Great Captain Island, or Greenwich Point, or some other fit place…in Long Island Sound."

Once it was decided to construct the beacon on Great Captain Island, the federal government purchased a 3.5-acre piece of land on the southeast portion of the island for $300 from Samuel Lyons, the proprietor at the time.

A contractor by the name of Charles H. Smith was commissioned for the project. When the new lighthouse officially began its duties in 1829, the total cost of the undertaking came in under budget at $3,455.17. The lighthouse keeper's accommodations consisted of a five-room living area, and the light design was a ten-lamp reflector system, allowing the beacon the ability to warn mariners from many directions.

Since the Greenwich beacon was to act as a guide for captains voyaging past Stamford and New York, it was a disappointment when a report written by Lieutenant George M. Bache of the U.S. Navy nine years after it was officially put into operation pointed out a few flaws:

> *Its elevation is 62 feet and limit of visibility 14 miles; but it is barely discernible in clear weather at a distance of 9 miles…The tower…is of rough stone, and is badly constructed; the mortar used in the masonry has not hardened, and the walls are cracked in several places.*

The lighting apparatus consists of ten lamps, with parabolic reflectors, arranged around two circular tables, and showing light in every direction...The reflectors are 14½ inches in diameter...the silver is much worn from their concave surfaces...The condensed moisture in the lantern occasionally freezes on the glass.

More than ten years later, George W. Anderson's 1850 inspection report was not much different:

Light-house is leaky in the tower, and needs to be repainted and whitewashed. Dwelling is leaky about the windows, and I suppose always was. Lighting apparatus is miserable...The whole of the establishment is in a neglected and filthy state. Lighting apparatus ought to be new, and there ought to be a new keeper, or the present one made to keep things in better order.

The only improvement that came from the report occurred in 1858, when a new lantern with a fourth-order Fresnel lens made by L. Sautter of Paris was installed. Eventually, it was determined that an entirely new structure was the wisest way to go in order to make things right, and on March 2, 1867, an allocation of $12,000 for such an endeavor was agreed to.

This time around, the lighthouse board decided to use a popular design that had worked well for other lighthouses along the New England waterfront. The basic blueprint featured a solid and secure granite foundation with a fifty-one-foot cast-iron light tower on top. A few of the other lighthouses that saw great success with this model included Sheffield Island in Norwalk, Plum Island in New York and Block Island North in Rhode Island.

The keeper of the light from 1871 to 1890 was a Civil War veteran by the name of Worden. Many of the lighthouse keepers of that era spent their down time tending to gardens and raising chickens, cows and other farm animals on the island.

The construction of a new lighthouse proved to be a wise decision, as no wrecks were reported for nearly forty years, between 1850 and 1890.

An upgrade was made in 1890 that consisted of a new fog signal building boasting coal-fired boilers and a steam-driven fog whistle. Additionally, on June 10, 1905, a more modern foghorn, complete with thirteen-horsepower oil engines, joined the equipment inventory.

Apparently, however, the new fog signal was somewhat ill received by the coastal residents of Greenwich, as they claimed that the less-than-desirable

noise kept them awake at night. Shortly after, the signal was "repaired," and there were no further complaints.

There is a story from the early 1900s that tells of an especially harsh winter when the weather was so frigidly cold, and the wind unusually absent, that Long Island Sound froze completely over all the way to Great Captain Island and beyond. It has been noted that motorists would drive their automobiles out to the lighthouse and back without any problems!

During the late 1920s and into the 1940s, the lighthouse keeper was a man by the name of Adam L. Kohlman. Kohlman had a step-granddaughter who lived in Pennsylvania and often came to visit him at the lighthouse during her summer vacations. In later years, she shared her memories of those summers:

> *When school closed...they would come in and pick me up in the boat and I would stay all summer. There were always lots of visitors during the summer. My grandmother was glad for the company, but it proved to be a lot of work cooking large dinners to feed the gang.*
>
> *There was no telephone or electricity and all supplies and doctor visits were by the little boat. My grandparents had a large garden, which was very well tended, plus they raised chickens. The brass was polished and the paint always looked new, and the light was often inspected by the Lighthouse Service.*
>
> *My grandmother would often wake when a fog rolled in and turn on the foghorn without even waking my grandfather.*

When operation of the Greenwich light was transferred to the Coast Guard in 1939 (along with several other lighthouses up and down the shoreline), Kohlman accepted an offer to stay on as keeper. Unfortunately, while under government watch, his wife was unable to live at the light full time, so she took up residence nearby on the mainland.

Eventually, Kohlman was transferred to Throg's Neck in New York.

After Kohlman's stint, the light was operated by a team of four keepers at a time. Their schedule consisted of a twenty-four-seven watch, with only six days off a month. A trip to the mainland for supplies every once in a while was their only reprieve.

Spending this much time at the lighthouse during the winter months was rather challenging, to say the least, but the summer proved to be quite a different experience. Down time allowed the keepers the opportunity to fish and swim to their hearts' content.

The first group to man the Greenwich light under Coast Guard supervision included twenty-two-year veteran Chief Boatswain Mate John Bolger, eighteen-year-old Ronald "Lucky" Lepre, twenty-year-old Herb Gilchrist, twenty-six-year-old John Lamb and a black, part-chow dog named Jerry.

Although life at the light was often lonely and monotonous, those who kept watch were provided the luxuries of radio, television and a gym.

It was not until 1968 that the hand-cranking method of powering the revolving lens at the lighthouse was replaced with a more updated piece of equipment. A steel-built tower near the original light was constructed in 1970 and officially began operation on January 30 of that year.

The Coast Guard maintained the lighthouse until the early 1970s, at which point the Town of Greenwich took over the preservation of the historic landmark.

3

The Mills and
Local Industry

The first records of industry in Greenwich date back to 1641, when a border agreement between the town and Stamford refers to the building of a gristmill along the Patomuck River. Another reference reflects a 1688 approval granted to Joshua Haight for sawmill and gristmill rights at a site along the Mianus River.

With coastal industries beginning to make their mark, it was not long before the need for other shore-side businesses became a necessity. With that becoming a reality, the year 1696 entertained the first of many cargo-carrying vessels that would soon become regulars on the local horizon.

The Davis Mill went into operation in 1705 and was located in a prime area along the Cos Cob River. (As a side note, the Cos Cob River has also gone by the names of Brothers Brook and Davis Creek.)

The owner was Reverend Joseph Morgan, who had officially received permission to build on the property on January 9, 1704. At the time, church and town went hand in hand, and the proposed site of the mill was considered common land. Because of this fact, part of the agreement showed a somewhat "joint" interest in the mill project by both sides.

When the Davis Mill began experiencing great success, members of the church began to wonder if perhaps Reverend Morgan was spending more time at the mill and less time performing his tasks as minister. With others holding a different point of view on the subject, it was determined that there should be a vote on the issue. During a town meeting on July 20, 1708, it was decided that the ultimate decision would be a collective resolve by the other ministers of the county.

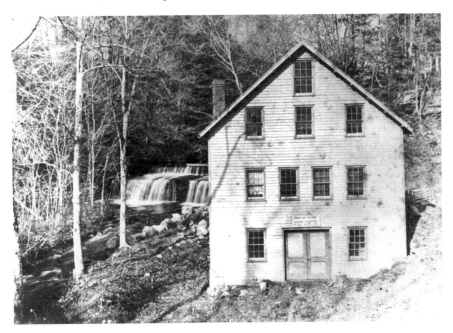

The old Cigar Factory. *Courtesy of the Greenwich Library.*

Caleb Knapp and Ebenezer Mead were selected to present the matter to the United Ministry of Fairfield County. After careful consideration, it was decided by all that Reverend Morgan should look in to hiring a competent manager for the mill in order to allow him more time to tend to his responsibilities at the church.

One would presume that that is how the story ends, but in an interesting twist of fate, it ultimately turned out that Morgan resigned from his position at the church and assumed the role of mill manager. A new minister was found for the church shortly after.

Morgan continued to run the mill at great profit for many years. Upon his passing, the mill went to auction, and a resident of Oyster Bay, Long Island, named Mr. Valentine made the highest bid. Although Valentine lived on the other side of Long Island Sound, he was quite familiar with the area of Cos Cob, as he ran a trading sloop that regularly frequented the Connecticut shoreline.

The Valentines owned the mill until 1761, at which point another man from Oyster Bay by the name of Thomas Davis purchased the business and the land it stood on.

Davis continued to run the mill as a lucrative company until the Revolutionary War, when it was taken over by his two sons, Elisha and Stephen.

The Davis Tide Mill site. *Courtesy of the Greenwich Library.*

Although brothers, Elisha and Stephen had quite different beliefs when it came to the war. As a matter of fact, Elisha was a Tory and was secretly grinding grain for the British, who were stationed on Long Island Sound. Stephen, however, was loyal to the homeland. When the war ended and the State of Connecticut finally caught up with what Elisha had been doing, it revoked his ownership rights to the mill. Ultimately, Stephen was able to acquire his brother's former share with the help of an act of the General Assembly and a peace treaty with Great Britain.

Running the mill solo, Stephen did quite well maintaining a profitable status for the business.

For more than a century, the Davis family owned, managed and successfully ran the busy mill. It had become such a special part of the Davis family story that each and every generation felt connected to the first day Thomas Davis ever set eyes on the property.

An excerpt from the book *Other Days in Greenwich,* by Frederic A. Hubbard, effectively paints the picture of the family sentiment:

For more than a century thereafter, the white-aproned miller that lifted the sacks of grain in at the old Dutch door and passed back the meal into the waiting ox cart, was a Davis.

Stephen Davis was laid at rest with his father on the hillside, in the woods just north of the railroad and was followed by his sons and his grandsons, all millers. There was Silas, Walter the "Commodore," Henry and last of all, Edward, who died in the winter of 1891.

He loved the old mill but he realized that its end had come and the day before the demolition began he went all through it in his half blindness. He passed his hands over the girders and the floor timbers and stroked the long shingles as though they were creatures of life and knew him and realized the parting hour. The warming pan, the old brass andirons and the ancient clock of his forefathers were all in the mill, but were taken out with tender care and not long since I saw the clock, now more than two hundred years old, still ticking the time away in the shop of Henry Schifferdecker.

Although the old mill is gone, all the surroundings are much as they were fifty years ago. The winding road with the wayside well, the picturesque walls, the granite bowlders [sic], moss-covered and overgrown with stunted cedars and climbing vines, the bold and wooded shores up and down the creek all lend a charm to Davis Landing that the removal of the old mill has not effaced.

A deed dated June 3, 1709, shows the acquisition by John Lyon of a mill and landing in Cos Cob.

On the third Monday in December 1763, the town granted David Bush permission to build a gristmill on Strickland Brook. This is presumably the property previously owned by Lyon.

An entrepreneur by the name of Justus Bush applied for permission in 1715 to construct a gristmill along Horseneck Brook. His request was granted, but a requirement was that he complete the project within two years' time and that he would "grind for the inhabitants of Greenwich what grain they shall bring to his mill to be ground."

It was also agreed that Bush would acquire the wood and stone that he needed to build a proper storehouse for the proposed mill from local land sources.

A similar grant was awarded in 1754, when Joseph Purdy received permission to build a mill along Dumpling Pond (the point at which Palmer Hill Road crosses the Mianus River). The catch in his agreement, however,

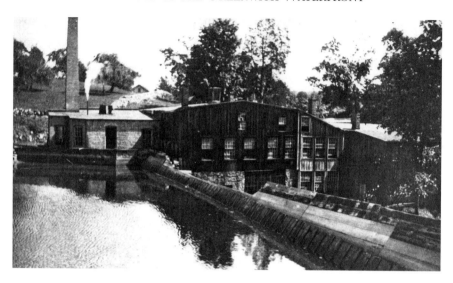

The Wilcox Mill. *Courtesy of the Greenwich Library.*

was that he construct a bridge with enough girth to accommodate horses carrying saddlebags.

Unfortunately, a destructive flood in 1787 washed out that bridge. A new bridge was conceived shortly after, this time with a floodgate and a crane for lifting vessels over the dam. In Mead's *Ye Historie of Ye Town of Greenwich*, there is a reference to a meeting held on October 15, 1787, regarding the proposal of a new bridge by property owners William, John, Samuel and Daniel Titus. Their request read as follows:

> *1ˢᵗ. The said mills to be built on said Purdy's old dam under the same restrictions as to grinding for the public as the mills above were.*
>
> *2ⁿᵈ. To lay out public landings each side of the river below the new dam as far as may be deemed necessary for the use of the public and to erect and keep in repair a sufficient dock on each side of the river, which shall be done by them, their heirs and assigns, as long as they or any of them occupy said mills.*
>
> *3ʳᵈ. The flood-gate shall be so constructed as to open something in the form of a field gate for the convenience of vessels, and a crane shall be erected for the purpose of hoisting boats and swinging them over the dam by the said Tituses, their heirs, and as in the second article.*
>
> *4ᵗʰ. They will also erect a good and sufficient horse-bridge across said river and keep it in repair on or near said dam, and likewise a good scow will be*

> *kept in the mill-pond for the use of the public at all times, they giving one day's notice previous to the wanting of it.*
>
> *Wherefore and with the advice of the civil authority of said town, notice is hereby given and the inhabitants of the Town of Greenwich are hereby warned to attend a town meeting at the meeting house in the West Society in said Greenwich on Monday the fifteenth instant October at two o'clock in the afternoon for the purpose of considering and discussing and granting or voting anything relative thereto, that they shall judge expedient, and the said John, Samuel and Daniel, with the assistance of Colonel Thomas Hobby, Jonah Ferris, Nathaniel Mead, Jonathan Coe and Abraham Hays, are hereby empowered to notify all the inhabitants by reading to the legal voters in the hearing of their families.*

Apparently, the request received the following response:

> *That instead of a horse and foot bridge mentioned in the petition, the petitioners are to erect and maintain a sufficient cart bridge across said river which together with the mills and other articles enumerated in their propositions are to be completed within four years from the date of this grant, and that Messrs. John Mackay, Jabez Fitch and Seth Palmer (the present selectman), with Messrs. Samuel Peck, Samuel Lockwood, Jr., Nehemiah Mead, Abraham Mead and William Bush, be a committee to covenant with the petitioners in behalf of the town for the purpose of conveying the right of this town to the premises unto the petitioners, and to ascertain the dimensions of the landing places proposed in said petition, and that said committee or the major part of them shall covenant and contract in behalf of this town shall stand good and firm as if the same were done at this meeting, and that should the petitioners fail in their engagements with said committee, the privileges hereby be granted to them will revert to the town.*

Coming up against much protest, the property was eventually deeded to Peter A. Burtus and Company. During a town meeting held on December 27, 1796, it was agreed:

> *That on condition that Peter A. Burtus and Company make the present town dock adjoining their mill eight feet front bigger than it was according to covenant with the Tituses, which is 30', and then the town dock will be*

38' in front, in which case said Burtus and Company is to have an addition of 14' in front southerly from the original grant.

Jeremiah Mead, son of Caleb Mead, acquired ownership of his father's land in 1751, after Caleb passed away at the age of fifty-six. It is believed that this is when the family property at the former Stonybrooke location first began operation as a mill site. Depending on what source you refer to, some say that it was originally a cider mill, while others believe that it was a sawmill. A sawmill seems more realistic, as it appears that most of the houses constructed during that period were built using materials that were sawed at the Mead mill.

Thomas Davis acquired a tidal gristmill located in current-day Bruce Park in 1761. The mill flourished for nearly three generations of Davis family members. Elisha Davis (1737–1813), Silas Davis (1772–1868) and E.N. Davis (1815–1892) successfully ran the family business through the late 1800s. In addition to earning the reputation of running a fine mill by all standards, Elisha Davis was also credited with creating a pivoting-cup, conveyor-built system that was utilized in mills across the country.

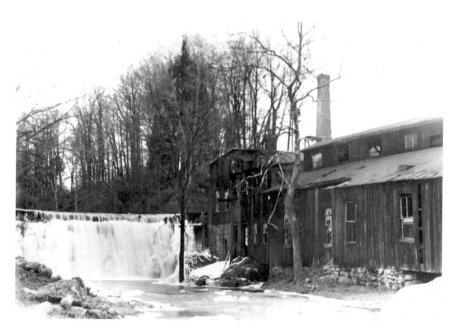

Another view of the Wilcox Mill. *Courtesy of the Greenwich Library.*

The Glenville Lead Works was a busy site during the early part of the eighteenth century. The company made litharge (a natural mineral form of lead oxide), red lead (used in paints, glass, pottery and packing for pipe joints), lead for paint and lead shots. During the Civil War, it also made blankets.

The Byram River was home to a variety of mills over a period of about 150 years. They included a woodworking factory in the Riversville area, a furniture factory, the Reynolds Felt Hat Factory and the Russell, Burdsall and Ward Bolt and Nut Factory. These businesses flourished back in the day due to the fact that Byram Falls was a great source for water power.

The American Felt Company site history can be traced back to the 1790s. At that time, a cotton and gristmill stood in that location along the Byram River. Later, in 1820, it was converted to a stone mill. Felt production at that locale found its official start in 1851.

Two granite dams were built on the river after the Civil War. One was constructed by the owners of the Hawthorne Mill and the other by the former Russell, Burdsall and Ward plant. Products used to be shipped from Glenville to Port Chester on the river launch *Glenville*, which was owned and operated by the Studwells, a prominent family who resided in Port Chester.

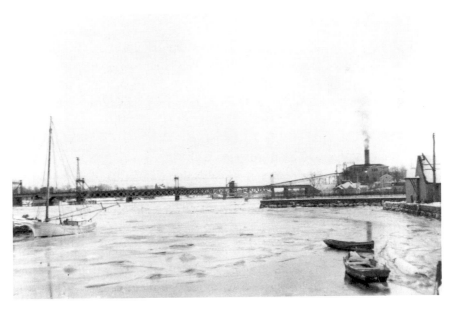

The Cos Cob Railroad Bridge and Power Plant. *Courtesy of the Benton Museum at the University of Connecticut, from the collection of the Greenwich Library Oral History Project.*

The Cos Cob Railroad. *Courtesy of the Benton Museum at the University of Connecticut, from the collection of the Greenwich Library Oral History Project.*

A new building was constructed on the original property in 1881 by the Tingue Company and the House Company, as they each had an interest in the felt industry.

The Tingue Company was a large Chinese hand laundry supply company based in Brooklyn, New York. In those days, men wore shirts that were cleaned with large amounts of starch. They were then ironed on a thick piece of white felt, also known as laundry felt. That type of felt was one of the mill's products.

The House Company made woven felt products, such as those used on billiard tables and on the inside of pianos.

The new building was one of the first in the area to use electric lighting and was built with long-leaf yellow pine in what was known as a New England balloon-type blueprint design.

The Rolling Mills, also known as the Greenwich Iron Works, was originally designed by a native of England named Robert Cox. Cox had been an ironworker his entire life "across the pond," and when he saw the potential for a piece of property along the northern section of the Mianus River to build a mill, he jumped on it. Once he acquired ownership, Cox immediately began construction on his project. The doors officially opened in 1829.

Shortly after, Robert's brother, William, joined the team, and the business name became the Cox Brothers. Unfortunately, the family duo did not fare as well as they had hoped, so the business was put up for sale, eventually being sold to the partnership known as Douglass and Gold. Still experiencing a difficult time of turning a profit under its new ownership, the mill would see a handful of turnovers and new owners during the ensuing several years. A man by the name of Mr. Roberts followed Douglass and Gold and then James H. Holden and Barrington Hicks; finally, in 1857, John Hughes took over. With his interest invested in shares of the business, Hughes managed the mill until 1861. During that period, the mill focused on the production of axe iron, tires, horseshoe nails and rods.

When the Civil War broke out, Hughes took on a business partner by the name of Lorenzo Finney. Reevaluating the market, they both agreed that it would make good sense to specialize in spike iron production. With Finney pretty much taking the helm, choosing the spike iron business proved to be a wise decision in a relatively short amount of time. By the third year, in 1864, the mill showed a net profit of $75,000.

Once the war ended, the business took a hit, and profits quickly diminished. Knowing that they could not stay on a sinking ship for too long, Hughes and

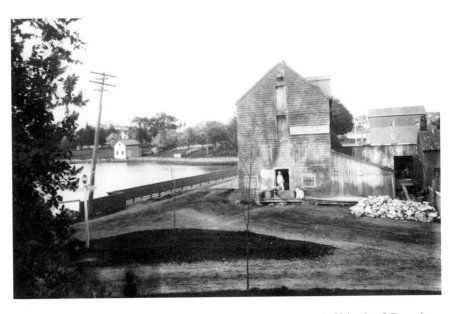

One of the early mills in Cos Cob. *Courtesy of the Benton Museum at the University of Connecticut, from the collection of the Greenwich Library Oral History Project.*

Finney sold the company to Pettit, Ayres and Davenport, which, at that time, owned the Stillwater Rolling Mills along the Rippowam River in Stamford. Under new ownership, the mill did quite well until about 1879.

It was at this point that great numbers of mills were beginning to spring up at locations much closer to Long Island Sound, and by 1880, it was decided to close the doors to the northern Mianus River mill for good.

Pettit, Ayres and Davenport also owned the Wire Mill, which was located near the Rolling Mills. The Wire Mill produced pump chains and fine wire. With hoop skirts for the women being the popular fashion during that era, the mill had a steady flow of orders for the latter. However, once the fad began to fade, the Wire Mill began its ultimate demise.

Swan's Paper Mill was another mill located along the Mianus River, snugly situated between the Rolling Mills and the Steep Hollow District Schoolhouse. Constructed by Walter Swan about 1800, the mill produced the highest quality of linen paper. Its major customers were retailers of writing paper and ledger paper. When Swan unexpectedly passed away in 1825, his wife and son continued to run the business with great success. Sadly, the mill was lost to a devastating fire just a few years later.

As fate would have it, Swan's daughter eventually married Henry Cox, a man who would bring her father's property back to life. This time around, the idea was to construct a sawmill, and with the help of Charles Stevens, who erected lathes in a section of the old building, they were able to successfully manufacture axe handles and carriage wheel spokes. However, when their hickory supply started to diminish, so did their ability to produce. Once again, the doors at the site were closed.

Shortly after, George Peabody saw the opportunity to make hand sewing machines at the abandoned sawmill. Turning a profit for quite a while, Peabody ultimately followed in the steps of his predecessors, and yet another business came to an end.

Next to try his hand at the unlucky location was the famous inventor Simon Ingersoll. It was not long, however, before Simon passed the torch to his son, S.C. Ingersoll, who in turn handed it over to Mr. Carter, who used the building for making equipment that ground shoddy (a type of material). That worked out quite well until about 1869. It was then that Mr. Cox came back into the picture and transformed the property into a country cider, saw and feed mill. That is how the mill spent the ensuing forty years, until a fire completely destroyed the facilities in the summer of 1909.

The Rippowam Woolen Manufacturing Company produced top-quality horse blankets and carriage robes from January 1896 to November 1899 along the northern shores of the Mianus River.

The Mianus Manufacturing Company was incorporated in 1899. The site of the old Rippowam Woolen Manufacturing Company was its new home, officially acquiring the property on November 2 of that year.

The officers of the company were president Thomas I. Raymond, vice-president Whitman S. Mead, secretary Minor D. Randall and treasurer and general manager Frederick A. Springer.

The company saw great success in a short amount of time as a result of good management, a strong staff and a quality product. Its clientele list quickly spread to include every state in the country. The addition of automobile robes to its inventory increased sales all the more. Automobile robes were in high demand during that time, as they were used for lining in fur coats, velour gloves, clothing and a number of other products.

Although the fur business was thriving, imitation fur was also gaining in popularity. To keep up with the changing trends, the Mianus Manufacturing Company began offering a variety of imitation fur products in 1907. For a period of time, the Greenwich-based company was the largest distributor of such items in the country. One of its regular clients was a very reputable horse-blanket business that employed some forty-eight salesmen just to cover their customer base.

The Volunteer Rock Drill Company was a venture that found its start in the Sound Beach area of Greenwich on March 24, 1891. It was created as a joint-stock company that specialized in the manufacture of steam drills. After five years of operation, it eventually closed its doors.

The east side of the Mianus River in Riverside was home to the Continental Mower and Reaper from 1865 to 1867. The business was another joint-stock endeavor that started out with a capital stock of $100,000. Its products included mowers, reapers and a number of other agricultural items. Shadrach M. Brush was the president of this rather large manufacturing plant, located just south of the drawbridge. Many local farmers were regular clients of theirs.

Unfortunately, the business could not turn a respectable profit, so it was sold in 1867 to Martin H. Shepard. Shepard immediately converted the business to a cottonseed oil company. It maintained that status until 1870, when it opted to relocate to New Orleans.

The Mianus River was clearly a popular location for potential businesses. The Brooklyn Railway Supply Company set up shop there in 1890,

manufacturing railway sweepers, apparatus, furniture and other related products. Eventually, the company changed names in December 1904, becoming the Mianus Motor Works. With a capital stock of $100,000 to work with, the newly created business began production of engines, motors, power-generated accessories, wooden boats, metal boats and all the extras that go along with yachting. The business eventually grew so large that, in August 1910, it moved its operation to Stamford.

Three business partners—William Cantrell, Thomas Gilbert and John Midwinter—purchased the old saltworks on the David Bush property in Cos Cob in 1848. Their intention was to utilize the land as a shipyard. However, on November 23, 1848, Cantrell, Gilbert and Midwinter sold their waterside acquisition to a man by the name of John Duff. Three years later, in 1851, Duff brought in William White as a business partner. Three more years passed, and then the two introduced another partner, Charles Burns.

The busy shipyard was successfully managed by White, Barns and Duff through 1855, when Denom Palmer made an offer to buy out White and Barns. From that point on, the business was known as Palmer and Duff. There was a short stint when Silas W. Knapp joined the team in 1866, but the company reverted back to Palmer and Duff after his passing in 1870.

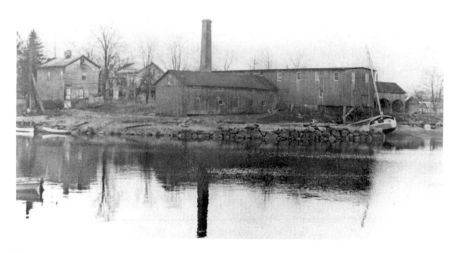

The Palmer & Duff Boatyard. *Courtesy of the Benton Museum at the University of Connecticut, from the collection of the Greenwich Library Oral History Project.*

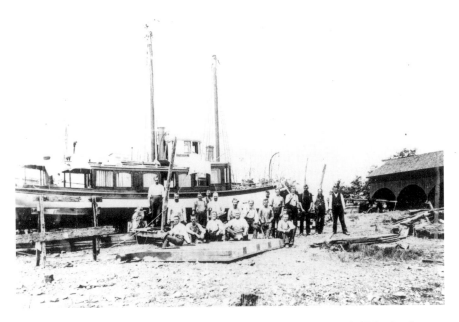

The Palmer & Duff Boatyard and crew. *Courtesy of the Benton Museum at the University of Connecticut, from the collection of the Greenwich Library Oral History Project.*

The Palmer and Duff Shipyard focused its business on repairing, overhauling and constructing sailboats. Palmer and Duff were mainstays in the coastal community until 1907, when both owners, well into their eighties at that point, decided to close their doors for good.

The Palmer Brothers was another nautically powered business, with its home in Cos Cob at Dumpling Pond. When it first started out in 1888, Frank T. Palmer was the sole owner, bringing in his brother not long after. Their inventory at the time consisted of telephone and electrical supplies.

When gasoline-powered machinery came on the scene a few years later, Palmer Brothers began producing gasoline engines and boat launches. With business thriving, the Palmers decided that they needed to expand, so they began construction on a new and larger facility in Cos Cob. At that point, they also agreed that the real money was in the production of launches. As a result of continued growth, expansions were also experienced in 1905, 1908 and 1909, and their customer base grew to include an international clientele.

The American Felt Company was originally founded in 1899 by a group of Boston bankers. (They eventually became known as the Consolidated

Investment Trust.) They were actually made up of a handful of smaller companies that included the Little Falls Slipper Company, the Union Color and Chemical Company, the Daniel Green Felt Slipper Company and the Boston Piano Parts Company, which were located throughout New York, Massachusetts, New Jersey, Rhode Island and Michigan. Their main headquarters was located in New York City. The first board of directors meeting was held on February 1, 1899.

Company houses were built all around the mill property, and a large tunnel was put in that ran from the foot of the dam all the way through the mill. Water wheels were placed approximately fifty to sixty feet below the dam, and they were what ideally propelled the generators.

One of the various buildings on the property was the Railroad Building. It was added to the design so that the New Haven Railroad would be able to bring the felt cars all the way to the mill. However, it turned out to be too difficult to build tracks through the dense rock in its path, so the New Haven Railroad was never actually able to make it there, even though the building had been completed.

What made the American Felt Company stand out from other manufacturers was that it produced every type of felt that was available on the market, unlike other felt companies, which only made certain types, such as that used for hats, tablecloths and more typical items. The American Felt Company's inventory included industrial felts used in the automobile, metal, filtration, appliance and chemical industries. Its impressive clientele list included such brand names as General Electric and Whirlpool. It was also very interested in research and development, often working with other industries to create new and improved felt products.

During World War II, the American Felt Company was commissioned by the United States government to make necessary felt components for the military, such as those that were used in the lining of all canteen covers.

By the time the war ended, the American Felt Company had accumulated nearly six years of back orders that had been previously placed by its regular customers. As one can imagine, the postwar schedule was a twenty-four-seven project.

Having pretty much worn down all the machines from the constant motion keeping up with the war efforts, a great expense was incurred to repair and replace the equipment.

One of the major projects of the American Felt Company came about in 1941, when it built a primary treatment system (a screening and settling base

located on the west bank of the river). Its purpose was to remove fiber that had gone into the river as a result of the production process.

Just when the mill was able to finally catch its breath, the Korean War broke out, and it was back to government work.

The company's main projects this time around included two types of military boots: a cold weather boot and a white felt boot. Both used felt in their designs and were in high demand.

Back to civilian life, piano felts were a whole business of their own, actually requiring a specific, separate mill within the American Felt Company complex. Steinway and Baldwin were just two of the regular piano customers of the Glenville company.

Many automobile companies such as General Motors and other industry headliners relied on the Glenville mill for their production lines. As a matter of fact, the American Felt Company was involved with General Motors' development of the first diesel engine for locomotives.

American Optical was a client for eyeglass felt. Pittsburgh Plate Glass and Ford used the American Felt Company for polishing felts. Grand Central Station in New York City used the mill materials to mount its rails in order to help absorb the vibration of the trains.

Clothing, such as the long felt skirts of the early to mid-1950s, also used the products of the Glenville-based company.

The American Felt Company produced some 140 million broad marker pens annually at one point in time. Interestingly, none of these products had the American Felt Company name printed on it until the 1960s, when the company was eventually involved with industrial filtration products. Before that, American Felt was primarily considered a raw material manufacturer.

The maple syrup industry used the mill to make wet filtration products for its filter bags. Septic System businesses also utilized the wet filtration process, as did paint companies such as Pittsburgh Paints. Masks used by firefighters were another product. Furniture refinishing cloths were a product as well.

The American Felt Company treated its employees quite well, even providing housing for them on the mill property.

With the business flourishing, it was absolutely devastating when the great flood of 1955 almost completely destroyed the Glenville mill. Near Byram Lake, the water began to back up quickly at first. In an attempt to relieve some of the stress, the plan was to open up the water pipe so that it would run into the Kensico Reservoir. Unfortunately, the wrong valve was inadvertently turned, and all the floodwaters went barreling down

the Byram River. The water flowed completely over both sides of the dam and onto the mill property. To try to save some of the mill machinery and materials, people began moving things up a few floors. They also took out all the windows and doors to allow the floodwaters to run freely through the buildings. Sandbags were placed all around the bases of the structures in an attempt to help reinforce the foundations. Amazingly, the business was up and running less than twenty-four hours after the water finally began to recede, even with the major cleanup and mud and stone removal that was required. As one could imagine, all the machines had to be washed down extensively before operation.

The company ultimately merged with Ruberoid about 1967. Ruberoid was in the building products business. After approximately six months with Ruberoid, GAF (General Aniline and Film Corporation) took over.

At the time, GAF made dyes, industrial chemicals and film. After about ten years, GAF phased out its felt division, which was the beginning of the end for the long-standing American Felt Company in Glenville. During the 1970s, American Felt was sold to a corporation that renamed it the Felt and Filter Company, based out of Newburgh, New York.

Today, the old mill property is home to condominiums, offices, stores and restaurants.

4

TOD'S POINT AND
OLD GREENWICH

Monakewaygo (or Greenwich Point) used to be home to the Siwanoy Indians. At that time, the primary use of the point was for fishing, and it was given the title of the "Shining Sands" by the local natives. Elizabeth Fones Feake (wife of Greenwich founder Robert Feake) acquired the land in 1640. Nearly a century later, the Ferris family purchased the property and maintained ownership for the ensuing 150 years.

Up until the 1870s, Old Greenwich was known as Sound Beach. Before that, it was called Old Town and, for a brief period, Old Greenwich Point.

In its natural state, Old Greenwich boasted beautiful and expansive fields, a magnificent assortment of trees, flowers and foliage and unrivalled water views. With rich and fertile soil everywhere one looked, farmers experienced great crop production. The land was so conducive to farming, in fact, that it earned the reputation for being the "garden spot of Greenwich."

Potatoes, celery, asparagus and fresh strawberries were regular products of the Old Greenwich farmers. Once the harvesting season ended on land, farmers turned to the sea and collected large supplies of local oysters. The Ferris family, who lived along the shoreline, was well known for their abundant amount of scallops fished during the late fall season.

At the turn of the century, Sound Beach Avenue was a very narrow dirt road with a trolley track that ran right down the middle of it. The stores lining the street used to be raised eight to ten steps so that shoppers could easily enter them in the wintertime when it snowed.

By the time the 1880s came along, word of this pristine waterfront section of Greenwich had reached beyond the local shoreline. A successful banker by the name of J. Kennedy Tod visited the area and immediately knew that he wanted to live there. Researching his options, Tod began purchasing parcels of property in 1884, one of them being the Ferris estate.

This real estate endeavor proved to be a three-year project, but in the end it was well worth the effort. Under Tod's ownership, the former "Shining Sands" would become one of the most famous spots in all of New England. Ever since, Tod's Point has retained its historical and extraordinary reputation.

Tod's initial concept of what he wanted his new property to look like resembled an almost resort-like atmosphere. Boasting magnificent views of Long Island Sound, top-notch swimming and bathing amenities and a first-rate golf course, Tod decided to name his waterfront acquisition Innis Arden.

The first step in attaining his vision required that the two nearby islands be connected. To achieve this, Tod brought in landfill and constructed a tide-control gate that allowed for a natural tidal marsh lake to be created.

Next on the to-do list was to construct a road and causeway that would provide easy access to the estate from the mainland. After that task was completed, it was all about developing the buildings, structures and landscaping that would ideally make Tod's Point a unique piece of the town of Greenwich's history.

A colossal thirty-seven-room mansion made out of stone was to be the main house. A humble guest cottage with fabulous views of the water, a fully equipped boathouse, a barn for the cows and sheep and a number of other buildings for a variety of uses were constructed all around the property. Tod's construction crew during this massive undertaking included thirty skilled stonemasons whom he hired from Italy. Four impressive stallions owned by Tod were often utilized for hauling winter coal from the railroad.

Tod earned his living as an investment banker and was a very successful, highly respected and well-liked man. He was quite generous to the Sound Beach Fire Department, as well as many other organizations.

Golf was one of Tod's favorite pastimes, and he played whenever the chance presented itself. With plenty of land at his new residence, Tod envisioned and then set forth designing and building his own personal nine-hole golf course right in his backyard. A charitable man by nature, Tod decided to allow his neighbors and guests staying at the local hotels to enjoy the shore-side links along with him. He even included access to the beach for the non-golfing residents to visit during the day.

However, Tod's generosity would turn on him as people began taking advantage of his kindness. For instance, the hotels began "advertising" that they had golf course passes, and people would drive their horses and carriages over the greens and fairways at all times, day and night. There were even instances when Tod would head out to play a relaxing round of golf only to find out that he had been bumped by some stranger at the first tee. It eventually reached a point where Tod reluctantly announced that only his personal guests would be granted permission to enter the grounds from then on.

Tod passed away in 1925, and his wife remained at the waterfront estate until she, too, passed away in 1939. With both of the Tods gone, ownership of the property went to the Presbyterian Hospital of New York.

Seeing an opportunity to acquire this preferred piece of real estate, the Town of Greenwich was able to negotiate a lease that would allow it beach rights in 1942. That was all fine and good, but the town was hoping for more. After some consideration, an arrangement was finally agreed to on December 13, 1944:

> *The Trustees of Presbyterian Hospital voted to accept $550,000 for 148.5 acres including Great and Pelican Islands. We have assured the citizens of Greenwich that it is our intention and desire that the use of Tod's Point should be along dignified lines without undesirable concessions or other features which would be unattractive or objectionable to the general neighborhood or to those making use of the property for bathing and wholesome recreation.*

An interesting piece of data is that 17,704 people visited the beach at Tod's Point during the month of July in 1943, but just a year later, 71,830 enjoyed the facilities during the same month.

The main house was eventually renovated in 1946 into a series of smaller apartments, with the intention that they were to be for returning World War II veterans.

Sadly, the mansion, which had stood as an impressive and highly respected icon along the Greenwich shoreline, eventually went into a state of great disrepair and was torn down in 1961.

Today, many of the original structures built by Tod remain at the point. A walk through the property reveals hints of the old golf course, offering glimpses into a bygone era and a sense of a time long lost to history. In the hearts of all those who have heard the tales, Tod's Point will forever be the grand estate it was always intended to be.

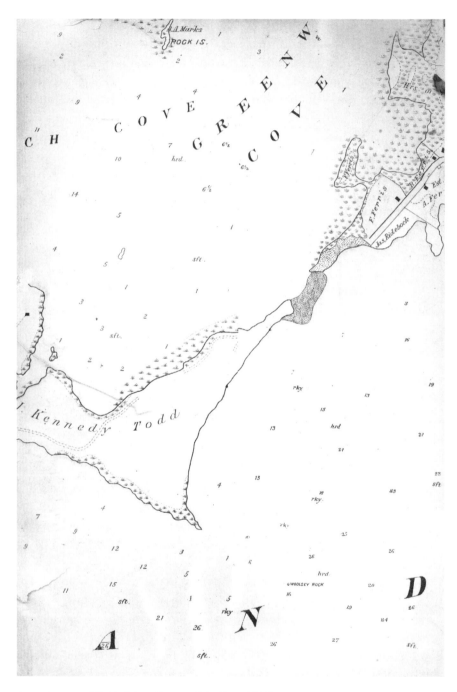

An early map of Tod's Point. *Courtesy of the Greenwich Library.*

Old Greenwich, in the meantime, had developed into quite the summer resort in its own right. The Kathmere Inn (also known as the Old Greenwich Inn) was typically booked the entire season. The proximity and easy access to the amusement park amenities found on Little Captain Island at the time was one of the attractions of this section of Greenwich.

The original summer cottage was owned by the Binney family and was referred to by many as Rocklyn. The Binneys enjoyed their warm weather visits to the cottage so much that they eventually decided to live in Old Greenwich year round. After purchasing a parcel of land from Oliver Ford a little farther inland, they had their cottage moved to the new site. Binney then ensued to make additions to the original structure during the late 1800s and early 1900s, ultimately designing a rather elegant home. He also continued to purchase more land in the area, including Oak Grove Beach, which he acquired in 1916. Binney built a lovely park area on what many people thought to be unusable swampland.

After a devastating fire destroyed much of the elaborate structure during the 1920s, the house was remodeled back to its original pristine condition.

William Marks, a member of the Riverside Marks family, owned farmland near the water in Sound Beach. He had many horses and donkeys on his property, as well as a pond that the neighborhood children used to skate on in the winter.

There was a quarry and lake in Sound Beach, though not connected. The lake was all enclosed, except for an opening where the tides from Long Island Sound would ebb and flow, filling the lake with fresh water when it was high. There was always a gondola or two kept at the lake, as well, for enjoying a quiet afternoon on the water.

The classic movie *When Knighthood Was in Flower* was filmed in Sound Beach. Many of the local children were cast as extras.

A man by the name of James Reilly owned a strawberry farm along Sound Beach Avenue. There was a yellow farmhouse at the front of the property and one huge strawberry bed in the back. Although Mr. and Mrs. Reilly mostly did the planting, weeding and cultivating themselves, they would hire people to pick the strawberries at the height of the season. The pay was two cents a basket, and it had to be done very early in the morning, about 4:00 or 5:00 a.m. The strawberry crop was primarily sold locally, but some was shipped to places such as New York.

Today, Old Greenwich remains an active residential community within the town of Greenwich, and Tod's Point continues to be frequented by thousands of visitors a year.

Other Subcommunities Along the Greenwich Shoreline

Cos Cob, Riverside, Bruce Park, Steamboat Road, Belle Haven and Byram

During the eighteenth century, Cos Cob became a thriving seaport, complete with busy docks, flourishing industries and magnificent homes built by seafaring captains who traveled to ports all over the globe.

Cos Cob was originally named for John Coe, an early English settler who owned the land around the mouth of the Mianus River and the Strickland Brook. Coe built a rocky sea wall (often called a "cob") to protect the shoreline. People would say that they were going down to "Coe's Cob." Eventually the *e* and the apostrophe were dropped, creating "Cos Cob."

Coe sold his property to William Hubbard in 1659 and then settled what is now Rye, New York.

Cos Cob became a bustling seaside village as far back as when the Native Americans lived on the land. Their village was named Petuquapaen and was located along the brook. Their chief went by the name of Mianos, or Myanos (the basis for the name of the Mianus River).

The tribe would fish from homemade dugout canoes. Along with the usual fish species one would expect to find, they also hunted seal, which were more abundant in those days. They often camped on Monakewaygo (Greenwich Point) when they were harvesting oysters, clams and scallops.

When the early settlers began building their homes during the 1600s, many of them earned their livings as "cowkeepers," often bringing their herds around the river for water.

During the mid-1600s, the local farmers acquired the deed to the land

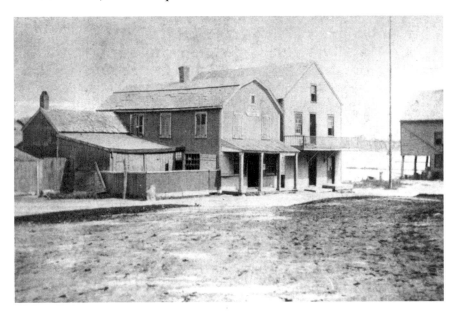

Cos Cob businesses at the Lower Landing. *Courtesy of the Greenwich Library.*

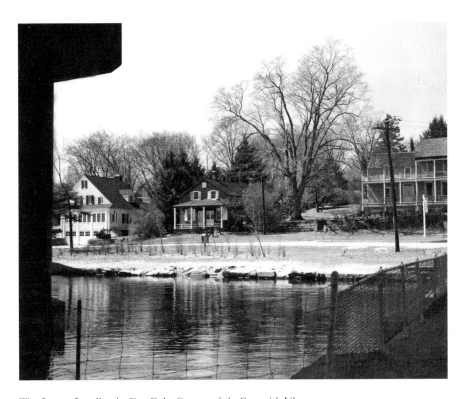

The Lower Landing in Cos Cob. *Courtesy of the Greenwich Library.*

between the Mianus and Byram Rivers, which at the time was known as Horseneck Plantation (from the Siwanoy Indian tribe).

The residents of Cos Cob constructed a dam and bridge across the Strickland Brook in 1763. A man by the name of David Bush (son of Justus Bush) headed up the project. Bush owned the gristmill located at the site of the dam.

Packet boats, market sloops and a variety of other seafaring vessels regularly tied up at what was known as the Lower Landing, which ran from the bridge to the harbor.

Many sea captains constructed their homes on River Road and Strickland Road. Fruits and vegetables were brought by ox- and horse-drawn wagons to the ships headed for the markets in New York City. When the vessels returned, they brought with them cargo and supplies for the local homesteads. There was so much action at the docks during that time that eventually a warehouse needed to be built in order to house all the supplies. Everyone enjoyed great success during that period.

When the Revolutionary War broke out, Cos Cob encountered numerous invasions and devastating raids coming from both land and sea. Of note, in February 1779, the British defeated General Putnam during a raid on Cos Cob, completely destroying the Lower Landing and the saltworks and burning two whaleboats and a sloop that belonged to David Bush.

Once the war was over, the residents of Cos Cob began to rebuild and reclaim their land. It was not long before they were once again shipping produce to New York.

The New Haven Railroad began service to the area in 1848, allowing many New Yorkers the opportunity to enjoy their summers along the local Connecticut shoreline. In addition, cargo originally brought by boat now had the option to be delivered by train. Even with the convenience of traveling by railroad, however, Cos Cob retained its reputation as being a major harbor and seaport village.

Today, Cos Cob is home to many families and businesses, and its shoreline continues to be utilized both commercially and recreationally.

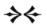

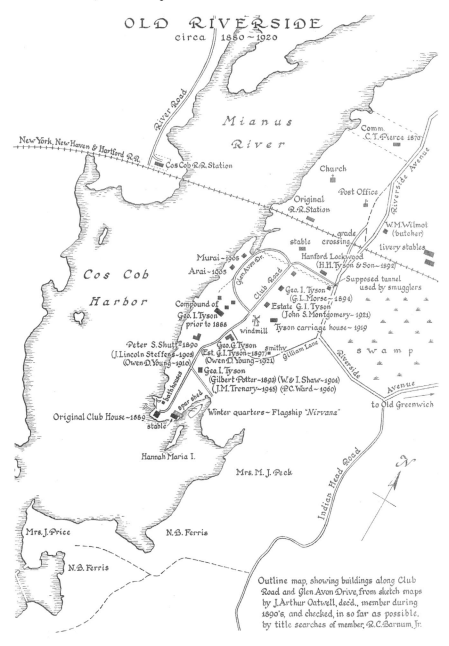

A map of Cos Cob Harbor and Old Riverside, circa 1880–1920. *Courtesy of the Riverside Yacht Club.*

Two of the longest-standing roads in Riverside are Riverside Avenue and Indian Head Road. That area was once known as Mianus Neck and eventually experienced its official name change to Riverside in 1870 as a result of the efforts of Luke A. Lockwood and Jeremiah W. Atwater. Fabulous Victorian mansions graced the shoreline of the Mianus River, and magnificent vessels sat peacefully at anchor in the harbor during that period.

Interestingly, the Riverside section of Greenwich, a now-flourishing community, was not part of the original deed of 1640.

Fishing and farming were the two major trades in Riverside for nearly two hundred years. The potato crop, especially, was so lucrative even into the mid-1800s that the current Riverside Avenue was referred to as "Potato Road." Most of the local potato crop found its way to the shoreline, where it awaited any number of cargo ships that would take it to market at distant ports.

Along the waterfront, there still remain the remnants of Indian transcriptions indelibly etched in the rocks. The Siwanoy Indians' menu typically consisted of clams, scallops and eels caught along the local Connecticut shoreline, so they clearly spent much of their time waterside.

Riverside was known for its healthy farmland in the early days, as well as for its many fine waterfront estates and summer cottages of all shapes, sizes and styles. The McDevitt Farm was one such estate and had cows, pigs, gardens, a barn and plentiful orchards.

A bridge was constructed in 1788 along the west bank of the Mianus River in Riverside, allowing local merchants the opportunity to increase their profits. However, after the bridge was completed, vessels that used to be able to travel all the way up the river were restricted to the mouth of the waterway. As a result, a landing large enough to accommodate all the boat traffic was constructed closer to Long Island Sound.

Gideon Ferris began operation of a quarry along the east side of Riverside in 1830. Barges from Manhattan regularly made deliveries of coal to the new dock, bringing back granite blocks to New York City in exchange. Among other structures, these Riverside-grown rocks were used in the construction of the Harlem River High Bridge.

The Willowmere section of Riverside earned its name as a result of Amasa A. Marks, who had acquired twenty-five acres from Charles B. Hendrie, John B. Hendrie and Henry Peck to utilize for his successful prosthesis manufacturing company in 1872. Marks utilized the local willows for the cutting, shaping and manufacturing of artificial limbs.

Upon completing the renovation of one of the existing buildings on the property into a sawmill, Marks went on to construct a steam mill along the lake that was located on the land for hole-boring and drying. The base products were then sent off by boat to be finished in New York.

After the Marks family divided and sold the Willowmere estate, the famous novelist Irving Bacheller acquired a parcel of the land along the southwest section of the property. Other successful publishers and writers who eventually took up residency in Willowmere included Alexander Grosset, Charles Duell and the Harcourt family.

Traveling by boat up the river, locals would pass by Ole Amundsen's boatyard (the old Marks sawmill), Ben Lockwood's Oyster House, Fes Palmer's Oyster Landing and W. Harold Palmer's Oyster Pond Wharf before they entered Long Island Sound.

Rookie oystermen were called "proggers" back in the day, and they often attempted to steal established oystermen's catches. This eventually led to the onset of the Oyster Wars during the late 1870s.

In an attempt to protect their rightful oyster beds, local oyster farmers set up a watch schedule. Resident Joseph Wilmot was a retired English sea captain, who, along with many longtime oystermen, spent much of his time helping out in this effort.

Riverside was a popular destination for summer vacationers at the time.

The Ford family owned property waterside. They used to rent out bathhouses along their private beach to the public. They also allowed "rights of way" to residents to access the beach on the other side of their land.

The Riverside Yacht Club was a focal point for everyone who lived in the community. Saturday nights at the club were famous throughout the area for their live music, dancing, food and drink. Festivities often ran well into the evening.

In an oral history interview with Riverside resident Charles Drake, conducted by Margaret J. French, Drake recalled, "In those days the Saturday nights at the Riverside Yacht Club were really quite an event. Nobody missed it who could possibly get there. They had music, you know, and you'd dance and sit around the tables and eat."

Since liquor was not sold at the club at the time due to Prohibition, people would bring their own homemade "remedies" or alcohol (unofficially) bought at the local drugstore. (An interesting side note is that there was quite a bit of rumrunning in those days on the Mianus River and in Byram. As the story goes, there was a shed of sorts on Captain Island where the bootleggers would unload the liquor off a variety of boats from different

locations. Then, when it was dark, they would make their deliveries along the local shoreline. A boat named *Old Glory* was one of the launches that would bring in the liquor from the larger vessels anchored offshore. Since there were not any police boats at the time, it was pretty easy for the bootleggers to run their business.)

During a brief period at the turn of the century, the Riverside Yacht Club was renamed the Riverside Marine and Field Club to help attract more people. It only lasted for about two years under that moniker before the name was changed back to the Riverside Yacht Club.

Catboat racing was very popular along the shoreline in Riverside during the late 1800s.

During the 1930s, a local boat designer named Russ Nall created the wooden Riverside dinghy. Initially, the plan was to build ten of them, but Nall ultimately was commissioned to complete sixty vessels.

Next came the Lightnings, with which Nall also was involved. The Dyer dinghies followed, and then the Sunfish.

One funny story about the early days of Riverside is about John Tyson, whose family owned all the property on Club Road right down to the Riverside Yacht Club during the early 1900s. Apparently, Tyson used to drive his automobile a bit "erratically" up the road, and when he did so, the children were told to get as far away from the street as possible. This was about 1907, when the sound of an engine starting could be heard nearly a mile away, so fortunately people had sufficient notice of when Tyson was heading out for an excursion in his automobile. The tale goes on to say that Tyson used to drive so fast that the dirt from the roads kicked up all over the place. For bystanders, safety was of the utmost concern.

Not far from where the Bush-Holley House stands today, a gristmill once flourished. At the time, its location was known as the Lower Landing and welcomed vessels of all sizes from many different ports of call. The Upper Landing was located farther up the river at the Post Road Bridge and was primarily built to accommodate two specific schooners that delivered cargo regularly to Greenwich. Onions, potatoes and apples were just a few of the more popular items. Soon to follow were other businesses, such as Johnson's Dry Goods Store, Newman's Billiard Hall, Newman's Hotel and three "watering holes."

Today, Riverside continues to thrive as a vibrant residential and commercial community.

The original property now known as Bruce Park ran from Steamboat Road to Indian Field Road and covered about one hundred acres of land. A man by the name of Robert Moffat Bruce owned this pristine piece of real estate for nearly fifty years during the late 1800s and early 1900s.

A tide mill was located along the millpond at the north end of the property during that time. Near the bridge were many millstones, each approximately six inches thick with a square stone in the middle and a square cutout of the middle that would fit over a socket. Around the outer edge were triangular or trapezoid-shaped stones that were all tied together with large wrought-iron bands about a quarter inch thick and six inches wide.

Since the mill was built at the north end of the property, it boasted an ideal location due to the fact that the Chimney Corner Creek opened directly into the millpond. Although there was not any water to speak of at low tide, high tide would bring in six to seven feet of water from Long Island Sound. When the tide arrived, the extreme water pressure that traveled through the narrow gully turned the wheels that would grind the grain.

The millpond became a great place for neighborhood children to go fishing and crabbing. There were several other small ponds in Bruce Park in addition to the millpond, including the "round pond," the "connecting pond" and the "swamping pond." Ice-skating was very popular in the winter as those three bodies of water were connected, innately offering some creative skating opportunities.

Gravel roads ran throughout the park during the early days. There were once many horse chestnut trees on the property, but they were unfortunately lost in a blight during the early 1900s. One year, a traveling circus came to Bruce Park. It brought horses, wagons, elephants, a variety of unique animals, tents, clowns and other attractions.

Bruce Park was a popular place, where many people came to visit or sell their wares. The umbrella man was a regular who offered to fix umbrellas and sharpen knives. The insurance man, the mailman, the grocer, the fish man, the junk man, the coal man and Hansen's Ice Wagon were other frequent visitors to this unique area along the Greenwich waterfront. These vendors would come by foot, bicycle or horse and buggy. In the wintertime, they would arrive by sled.

There was a cave in Bruce Park nestled within a group of rocks located between the round pond and the connecting pond. As the story goes, the

local farmers used to hide their tools and valuable equipment there during the Revolutionary War, so that the British would not be able to get them. Presumably, the cave appears on a 1940 tercentenary map drawn by Roger Selchour that reflects the period from 1775 to 1780.

The current-day Bruce Museum building dates back to 1853, when it was originally constructed as a home for Francis Lister Hawks, a lawyer, historian and clergyman. Robert Moffatt Bruce, a successful textile merchant and a member of the New York Cotton Exchange acquired the property in 1858 and lived on the estate until 1908, at which point he offered it to the Town of Greenwich. His only request was that it be utilized as "a natural history, historical, and art museum for the use and benefit of the public."

The first official exhibit to be presented by the Bruce Museum highlighted the works of local artists, most of them from the Cos Cob Art Colony and others that belonged to the Greenwich Society of Artists. It was held in 1912.

Following are some interesting facts about Steamboat Road, Rocky Neck and Mead's Point:

1) The first landowners to attempt to "tame" this wild piece of land were two brothers, John and Daniel Smith. Ultimately, the property went to the Mead family through marriage, Daniel Smith Mead being the original family member to claim rights to the land.

2) After Daniel Mead passed, the family eventually decided to sell the property. The Rocky Neck Land Company, considered the first official land speculators to purchase property in Greenwich, became the new owners of "Rockie Necke."

3) During the 1800s, Steamboat Road was known as Rocky Neck and was owned primarily by the Rocky Neck Land Company. Early records, dating back to 1725, note the property located south of the William H. Teed estate as "Rockie Necke." The landscape boasted an exceptional number of rocks and ledges, as well as many trees, weeds and wildflowers. The company eventually divided the land into individual lots in 1836, and the parcels were sold at auction.

4) The Stanton House was a popular hotel and restaurant on Steamboat Road during the mid- to late 1800s, as was the White House Hotel.

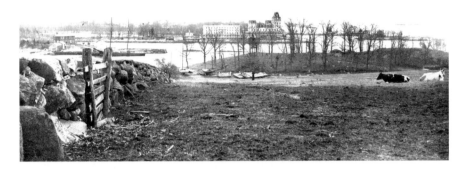

The Oliver Mead farm. *Courtesy of the Greenwich Library.*

5) Steamboats ran regularly back and forth from the old Peck's Coal Yard to New York City during the early 1900s. Some carried passengers and others cargo.

6) Steamboat Road was often called "Catfish Row" during the 1920s.

7) After World War I, the old Silleck House was bought, and the new owners converted it into apartments, calling them the Sun Dial Apartments.

8) An old map of Rocky Neck Point was titled as follows:

> *Map of eleven acres of land lying on Rocky Neck Point, Greenwich steamboat landing, laid out into building lots 50 feet front on the road, unless otherwise expressed upon the map and extending to the water. Surveyed October, 1836, and plotted from a scale of 132 feet to one inch by Wm. H. Holly, N. Currier Lith., Cor. Nassau and Spruce Streets, N.Y.*

Presumably, the original map was owned by Solomon Mead. Sections of the map include Field Point, Indian Harbor Point and Great (or Round) Island. The steamboat landing at the time is listed as six feet at low tide. A note at the bottom of the map states that "the above lots [were] to be sold on the 23d of March, 1837," probably announcing the previously mentioned auction by the Rocky Neck Land Company. The map was lithographed by Currier & Ives.

9) A description of the land at the time of the transaction was provided in detail in the book *Other Days in Greenwich* by Frederick A. Hubbard. It reads as follows:

I often talked with those interested in the venture and I recall very distinctly the details of the transaction as they were given to me and as they are found in the public records. It was a wild and rocky stretch with nothing but a cart path over the line of the present highway.

No attempt had been made to cultivate any part of it. Many of the primeval forest trees were still standing—great oaks that had stretched their limbs across the Indian paths of a century earlier. There were bowlders [sic] of enormous size covered with a wealth of moss, and resting in beds of lichens and ferns that grew with rank luxuriance about their base. One larger and more rustic than all the others was shaped like a great chair, filled with moss and backed with cedars over which the woodbine trailed in graceful profusion. It was well named the "Indian Chief's Throne." To cut such a piece of land as that into fifty-eight building lots seemed a wild and chimerical scheme.

But as I read the list of stockholders of the Rocky Neck Co. I find them all men of nerve and character, as far as I knew them, and I have a personal knowledge of all but three. These were John D. Spader, who held three shares, Benjamin Andrews, two shares and Thomas Simons four shares. Mr. Spader was the man who subsequently married a daughter of Silas Davis and the other two were probably residents of New York.

The other stockholders were Silas Davis, one share; Augustus Lyon, five shares; William A. Husted, two shares; Jonathan A. Close, three shares; Walter Davis, one share; Alvan Mead, one share; Solomon Mead, three shares; Daniel S. Mead, one share; Zaccheus Mead, Jr., two shares; Husted Hobby, two shares; Abraham B. Davis, three shares; and Thomas A. Mead, two shares. Each share had a par value of one hundred dollars.

10) The Rocky Neck Land Company was created as a joint-stock company. Its vision for the property was to include storehouses and a wharf that would allow for steamboat traffic to tie up and load or unload cargo and passengers. In other words, it was intended to be a preferred destination for all types of commerce.

11) If one were to take a look at the previously mentioned map of 1836, it would clearly show one acre located at the very end of the point that seems to stand out above the others. This particular parcel is of note, as it was originally purchased by Ephriam Mead and, in later years, would become the site of the Indian Harbor Yacht Club. (As a point of interest, the yacht club also acquired land on the east side of the peninsula that was owned by Charles T. Wills and once boasted a humble group of waterfront cottages.)

12) The site of the old Silleck House (or White House) once consisted of potato cellars (about 1837), some of which are still presumed to be discernible by the human eye. History tells us that the owners of the potato cellars included Thomas A. Mead, Solomon Mead and Zaccheus Mead Jr. The Silleck House, owned by Jared Mead, was constructed just one year after the potato cellars were built.

13) The Silleck House, although considered to be located in a prime location for those seeking rest and relaxation, struggled as far as the operation of the business. Mead eventually decided to sell his property to Mrs. Mary Dennis and Mrs. Fanny Runyan in 1849. The following year, Mrs. Dennis sold her share to Mr. and Mrs. Thomas Funston. When Funston's wife passed away in 1854, he sold their share to Thaddeus Silleck, who officially took ownership in May 1855. Converting the old building into an updated hotel, the new Silleck House experienced great success, surviving for many years in that capacity. As a matter of fact, the Silleck House earned boasting rights to being the "oldest hotel on either shore of the Sound from Sands' Point to Stonington."

Mead's Point was developed by the Mead family, who originally came here from England and before that France. They were successful in farming and business. Gabriel Mead was the first recorded family member to live in America. He arrived shortly after the *Mayflower* landed, initially making his home in Dorchester, a Massachusetts colony at the time. He and his wife had two sons, John and Joseph. As an adult, Joseph moved to Stamford about 1667, and his brother joined him in 1669. With the knowledge that this part of Connecticut offered great farming soil at a reasonable price, John was the first Mead to buy land in Greenwich and ideally set the ball in motion for the following generations of Meads.

Noah Ebenezer was the family member who had the original deed for the old Horseneck Plantation, which was acquired from the local natives. (As an interesting side note, that original document is kept in a fireproof container at the Greenwich Historical Society.) The deed has gone through many generations of inheritance, never leaving the family, even for a short while. The original property was used as a working farm with its property lines running from the railroad tracks along the east

side of Indian Field Road to the main road and all the way to the end of the point.

There were several barns, about fifteen to twenty cows, horses, chickens, ducks, cats, dogs and at least two yoke of oxen. They grew potatoes, oats, wheat, apples, cherries, peaches and quinces. There was also a rather large family garden near the main house. On the cove below the house, a stone dock was built. Vessels bringing produce to New York were able to dock there at high tide to load their cargo.

The Mead property consisted of nearly two hundred acres. The Meads' hired staff worked both in the house and on the farm.

Sandy Beach was at the end of the point, and many people from town would go there to picnic, swim and bring their horses, even though it belonged to the Mead family. Often, there would be fifty to one hundred visitors there at a time.

Today, Steamboat Road is home to a number of residential properties, businesses and the Indian Harbor Yacht Club.

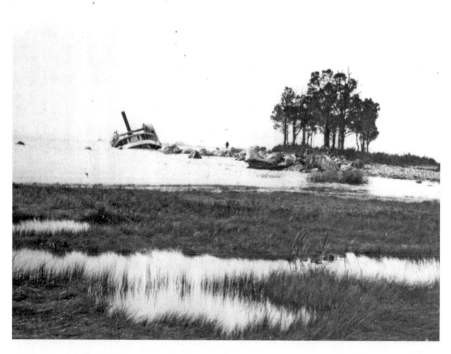

A boat grounded at Mead's Point. *Courtesy of the Greenwich Library.*

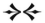

The area now known as Belle Haven was originally used by Native American tribes as a place to keep their horses. They constructed a fence that ran from the north end of Byram Harbor to Greenwich Harbor (a little less than a mile). Part of the horse pasture included a section of Field Point.

Eventually, the local tribes sold the property to the Mead family in the late 1800s. At that point, cattle were also brought in. When the property was later sectioned off and sold as individual lots, some of the new landowners included Charles W. Dayton, Robert Bruce, Thomas Mayo, Nathaniel Witherell, James McCutcheon, Edmund C. Converse and A. Foster Higgins. Some say that Higgins's wife is the one who gave Belle Haven its name.

In the early days, although there were many pathways (as there are roadways today), they were not marked with signs such as they are now. In an oral history interview with John D. Barrett Jr., conducted by Esther H. Smith, Barrett shared: "I can't remember the names of the drives, which in the old days were almost never marked. One was supposed to wander, and one had plenty of time, in horse and carriage."

The word about picturesque Belle Haven quickly reached New York City, and soon many New York residents began purchasing property along the elite Greenwich waterfront. With more and more people buying up the land, the roadways required upgrading, so formal streets were created (although still with dirt) with a European flair. This was evident in the many trees that were planted along the roadsides. Even today, those magnificent trees are a unique characteristic of Belle Haven. Elm trees, maple trees and chestnut trees were abundant back in the day.

The residents of Belle Haven were rather meticulous about their grounds. Finely clipped hedges and beanpoles that hung over those hedges nicely complemented each other. Magnificent flower gardens graced nearly all of the properties. Gardens were such a big part of the community back then that Mr. and Mrs. Leo T. Martin designed a breathtaking Italian version on their land that covered nearly a half acre. In addition to beautiful flowers, it also boasted a gazebo, teahouse and several statues.

Many of the homes that were built in the late 1800s and are still present in Belle Haven feature the original carports (or porte-cochères) from that era. They were very common back then, as people preferred the option

An early map of Belle Haven and Greenwich Harbor. *Courtesy of the Greenwich Library.*

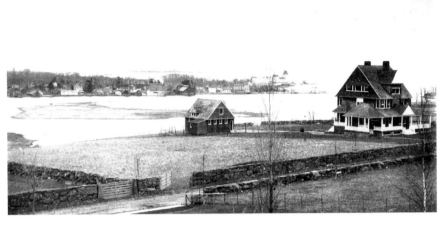

A panorama view of Belle Haven and Greenwich Harbor. *Courtesy of the Greenwich Library.*

of getting to and from their carriages and automobiles in adverse weather without getting soaked. Grand entranceway columns were also very popular.

Expansive circular porches were almost considered a necessity, and many can still be seen today. Traditionally, these fabulous porches were set at the northwest corner of the home so as to take advantage of the cooling breeze coming off the water during the hot and hazy days of the late summer months.

John McGlynn used to be the neighborhood lamplighter. It would take McGlynn the better part of three hours to light all of Belle Haven.

At the turn of the century, a beach club was formed in Belle Haven named the Belle Haven Casino. A unique widow's walk along the exterior of the clubhouse gave it a bit of "chic." The club offered amenities that included a beach, tennis courts, horse shows and swimming contests.

Yachting quickly became a favorite pastime, with rather large and impressive vessels being the flavor of the day.

John Barrett Jr., in his oral history interview with Esther Smith, shared the following about the waterfront during that period:

> *The harbor was a very picturesque sight in those days. It was a wonderful haven for the ancient schooners when there was real traffic on Long Island Sound, between New York and Newport and perhaps Boston. They would*

use it as a restover because they were sailing ships, carrying coal, sand gravel; heavy, heavy loads more easily transported by water.

At night here at Jack's Island, in this small harbor, two or three old schooners with gray sails would come in laden with coal or sand or rocks, and anchor the night, before sailing on to New York or perhaps it was a day's sail from New York on up. And I can hear in the summer evening, going to bed, the sails being let down, and the click-click-click-click. And if one wasn't up early in the morning, they'd all sailed away. But it was a fantastically pretty sight, which is now lost to history, the great commercial use of Long Island Sound as a means of transport for such as sand rock.

It has been said that "Beauty, Comfort, and a Magnificent View" characterized Belle Haven at the turn of the century.

The roads closest to the shoreline received an upgrade of heavy stone about 1907 to help deter the high tide flooding that often occurred and affected about five acres of coastal property.

A mobile water sprinkler used to regularly travel up and down the dirt roads to try and settle all the dust. That was a fun event for neighborhood children, as they chased the moving sprinkler, trying to avoid getting wet as they did.

Belle Haven was primarily a summer destination up until about the 1920s. During the winter months, the houses were shut down and boarded up.

The old bathhouse at the casino was quite unique. In an oral history interview conducted by Esther Smith, Helen Barrett Lynch recalled:

The old bathhouse…I wish I had a picture of that to show you because it was Victorian. Why anyone would even imagine a bathhouse that would look like it! It was gray shingle; it was full of turrets; it looked just like a gingerbread house. It smelled of wet wood always, and it finally was torn down, a great many years ago.

Lynch also shared her memories of life as both a child and an adult in Belle Haven:

Everyone had a boat of some size. We had a very happy life. It was such a simple life and yet all so much fun. We rode bicycles all over; we rode bicycles up to the village. And there were boys and girls just fishing, playing tennis. Always a tennis game. Always plenty of people, young people, to have fun with.

If you loved the sea and loved watching it, there was always something interesting happening in the harbor, the fishing boats and the yachts in the summer coming and going and sometimes lying at anchor nearby. And particularly it was interesting during the Prohibition. We became aware in a strange sort of way that we were very close to some very interesting activity.

My husband and I were living in my mother's house during the winter, just for one winter in the twenties. And the summer prior to that, when we'd been with my mother from time to time, we had noticed lovely lights in a house, apparently on the terrace, across the harbor. Some evenings they were a lovely blue and green, and sometimes they were red and yellow, and they seemed to change from night to night. We thought nothing of it and rather enjoyed them.

And suddenly, coming back from New York in the middle of the winter on a very snowy, icy, cold night, my husband and I looked across the harbor again and here were the lights, and we wondered why they would be used at that time. Then we began to realize that there were some of the old-time schooners with the gray sails—very picturesque in the days when they worked the quarries up the inlet but rarely seen at the time I'm speaking of—and we became suspicious that something strange was going on.

Later it was confirmed that they were using the ships to bring in liquor; would lay off the harbor behind the islands until they saw the proper lighting in this particular house. So it was rather interesting. We really watched the lights then! And I never knew exactly what happened. I hesitate to say that the bootlegging was happening, but I do think, if my memory serves me right, that the bootleggers were finally caught. It seemed strange suddenly to be aware that it was happening under your nose!

When asked about the yachts that sailed in the harbor, Lynch remembered:

The Indian Harbor was really full of them at that time. They came and went. Many of them were large enough to cross the ocean. Of course, Commodore Benedict's steam yacht, the Oneida, *was very well known and he traveled everywhere, up the Amazon River and across the ocean, I think, several times. And my father quite often went with him when he could get away from business to do it.*

Then there were other large boats. Mr. and Mrs. Frank Gould lived for four or five summers in the house next door to my mother and father, and they had a beautiful yacht lying off at anchor. It was in full view of our house. And, of course, during the racing season the big racing schooners and the big

racing sloops came and went. Some of the trial races for the Newport, for the international races, were almost always held in Long Island Sound. They had to be beyond the islands but we at least could see them and it was a pretty sight.

Mr. George Pynchon actually sailed in many of those big races, and his home was on Field Point just around the corner from us. His daughter [Beatrice] was one of my dearest friends and I had the opportunity of actually sailing in some of the trial races. Never, of course, in the big races. But that was an experience. We were little girls at the time, and I remember two or three different times we were told we could come with him if we would sit absolutely still, in the cockpit. That was not a very comfortable spot; it was just a little hole in the deck. We had our lunch in a paper bag and we were hardly able to open the paper bag to get the lunch out because any rustle disturbed the crew. And he stood at the helm. He had eighteen or twenty in crew, all beautifully outfitted in their sailor suits. He was a short man and quite lame, and to see him handle that boat was just fascinating.

These boats were much larger than the sloops that are used today for the international races…Of course, they tried different types of masts and different types of keels to try to pick the fastest possible boat…The crew has to be enormous to handle a boat that size and to do it efficiently, and you can't have anything in the way.

If you live by the sea, there's never really a moment when something isn't happening. Even in winter the sea is beautiful. On the gray days the sea becomes black against the white snow. It's like an etching.

To visit Belle Haven today, one would experience a fabulous step back in time, as much of the original architecture and landscape continues to characterize this prestigious community of Greenwich, ideally representing a wonderful era in both maritime and coastal history.

The area of Byram was at first put on the back burner for Greenwich settlers, as it boasted a rather rocky coastline and hosted a number of quarries, making it difficult to build upon. On the flip side of its challenging terrain, however, was the allure of a quieter, more subdued environment for those not necessarily searching for the constant hustle and bustle of city life.

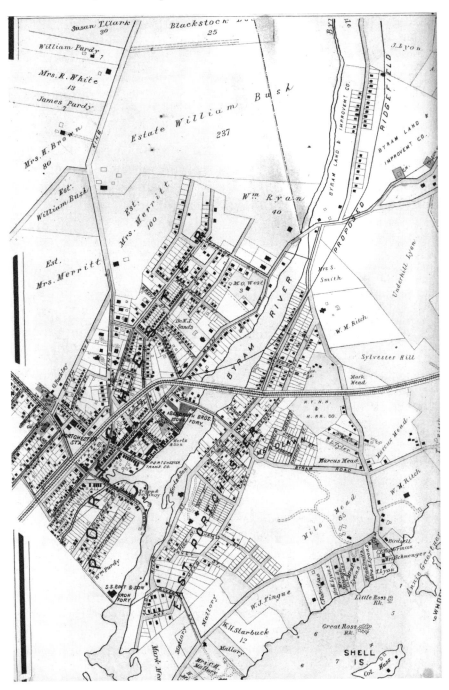

An early map of the Byram River area. *Courtesy of the Greenwich Library.*

One of the first to attempt living there was Thomas Lyon, who came from England and settled in Byram during the 1660s. He chose a large piece of land that bordered Byram Shore, Calves Island and Rye, New York. His first wife, Martha Joanna Winthrop Feake, was the daughter of one of Greenwich's earliest settlers, Robert Feake.

The rocky landscape of his estate was ideal for raising sheep, and eventually a weaver's shop was constructed just down the road. The current Weavers Street reflects that period. During the Revolutionary War, the main house was used as a lookout point for the soldiers who were guarding the nearby bridge. Today, the original Lyon home is one of the oldest houses in Greenwich still standing.

Another resident of Byram was Captain George W. Martin. Martin owned several oyster beds off the Byram shoreline during the 1800s. He was a hardworking man, who earned much respect from his colleagues and friends. A charming tale has been passed down over the years about Martin's wedding day on November 19, 1854. As the story goes, Martin and his brother, Jarvis (also his best man), put on their boat clothes, boots, winter undergarments and heavy woolen overcoats in preparation of making the voyage to the wedding ceremony in New York City. Of course, they also brought with them their "Sunday" outfits—blue serge suits, white formal shirts, black socks, black ties and black shoes.

As they raised the mainsail on the vessel that was to take them down the river and out to Long Island Sound, the tide was just beginning to rise. Navigating through the channel, which was lined with eelgrass and other sea growth on either side, Martin carefully and deliberately made his way. There was a noticeable north wind following behind the boat, so Martin made a point to keep an eye out for the sandbars. As he passed by Fox Island, the High Sand Banks on Manursing Island, Black Rock and Captain Island, a two-masted lumber schooner carrying a full load of cargo suddenly overtook him.

Successfully riding out the great ship's wake, Martin and his brother continued on, eventually tying up at the Water Street dock. They then changed into their wedding clothes and made their way to the Salem Baptist Church, where Martin and his bride to be, Emily, were married.

After taking their vows and enjoying a wonderful reception at the home of the bride's mother and father, the new Mr. and Mrs. Martin packed up all their wedding gifts and headed to the boat to begin their honeymoon.

As they sat in the stern enjoying the light sea spray hitting their faces, Mr. Martin remarked that the unexpected "seaman's rice" was a sign of good

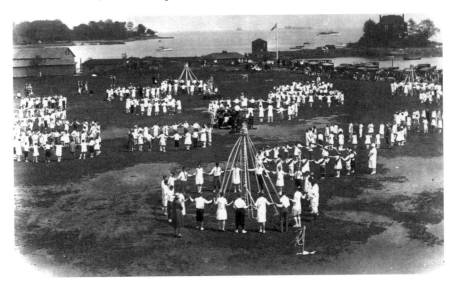

Maypoles in Byram, a very popular activity at the turn of the century. *Courtesy of the Greenwich Library.*

luck. Sure enough, that first night of marital bliss led to years of happiness, with many children, grandchildren and great-grandchildren.

Down the road from the Martins' waterside home was the Hendroth Brothers Foundry. Often referred to as the Eagle Foundry, it opened its doors in 1840 as a humble factory and eventually grew into a popular and lucrative international business producing stoves and furnaces. In its heyday at the end of the nineteenth century, the foundry employed seven hundred workers and occupied two blocks of property between Mill Street and Willett Avenue.

The company logo was the fork, and it was displayed on countless Eagle furnaces, steam and hot water heaters, soil pipes, kitchen and parlor stoves and a variety of other cast-iron products.

The easy access of the river running to and from Long Island Sound allowed the barges to comfortably come and go as they pleased with their shipments.

A man by the name of George Merritt owned the old ironworks forge located on Mill Street. Many remember him with a cigar in his mouth and wearing a leather apron. Merritt was in the business of fixing axles and steel-rimmed wheels that were used on buggies and wagons. He also shoed horses and created impressive metal objects such as iron fences and the like.

Byram, in step with its neighboring communities, continues to thrive both commercially and residentially.

THE RIVERSIDE YACHT CLUB

The Riverside Yacht Club celebrated its official start on May 25, 1888, with George I. Tyson standing at the helm of the historical event. Tyson was a passionate yachtsman and successful businessman who lived along the waterfront in Riverside.

It had been Tyson's original vision to introduce the concept of a new yacht club to ten of his closest friends and colleagues. To sweeten the pot and hopefully enhance the appeal to his audience, Tyson offered about an acre of shorefront property as the site of the proposed club, as well as his financial support in paying for the entire cost of constructing a clubhouse. As one might imagine, the response was unanimous in favor of the new yacht club, and it was full steam ahead from that point on.

By formalizing the decision, the Riverside Yacht Club became the second yacht club to be created in Connecticut and the eighth on Long Island Sound between City Island, New York, and New London, Connecticut. (This recognition is based on yacht clubs that still exist today, as there were a handful of other start-up clubs that did not survive long enough to be considered.)

The first officers of the newly formed Riverside Yacht Club included George I. Tyson, commodore; P.S. Schutt, vice-commodore; W.A. Hamilton, rear commodore; P.C. Ralli, secretary; J.E. Peck, treasurer; and E.F. Lockwood, measurer. The board of trustees consisted of A.M. Bruch, Luke A. Lockwood, C.T. Pierce, Gilbert Potter and George G. Tyson (son of the commodore).

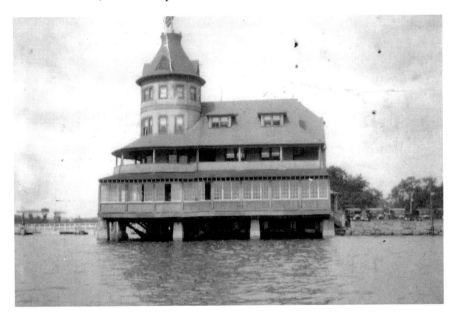

The Riverside Yacht Club during the early years. *Courtesy of the Riverside Yacht Club.*

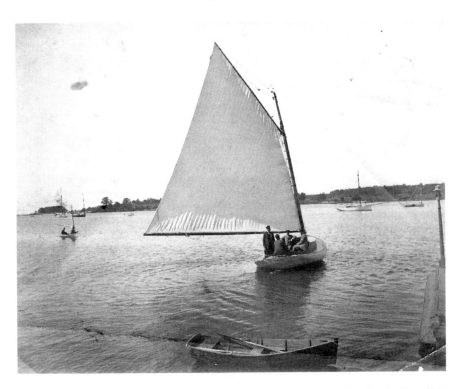

Sailing off the Riverside Yacht Club during the early 1900s. *Courtesy of the Riverside Yacht Club.*

The summer of 1888 was a busy time, as deciding on the proper design for the new clubhouse was a major priority. The intention was to have the clubhouse up and running by the spring of the following year, so time was of the essence.

Before venturing further into the history of the club, let us first take a look at the man who made it all happen.

Tyson was what many called a self-made man. During the Civil War, he served as a captain in New York's Seventh Regiment. Born in New York in 1835 into a wealthy family, the prosperity only lasted a short while. With businesses and the economy struggling, the Tysons suffered a huge loss in 1837. However, young Tyson was fortunate to have had a great role model

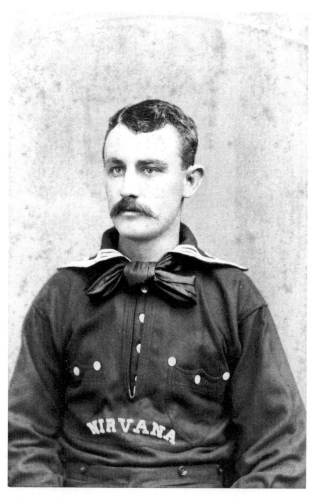

Commodore George Tyson. *Courtesy of the Riverside Yacht Club.*

in his father, who instilled in him a strong work ethic, the desire to succeed and some good old-fashioned determination.

By the time he was seven years old, Tyson was already holding down a job as a newspaper delivery boy. In order to complete his route before school, Tyson had to wake at 3:00 a.m. every day of the week. It turns out that this discipline would stay with him for years to come, as Tyson started his day well before sunrise for the rest of his life.

Adding more routes to his newspaper delivery schedule for the ensuing ten years, Tyson had enough money and foresight to open his own newsstand by the time he was seventeen. That was to be the first of many similar ventures, ultimately leading Tyson to an opportunity to run the stand at the Fifth Avenue Hotel in Manhattan when he was only twenty-four years old. His reputation quickly preceded him, as a number of other prominent New York City hotels requested his services as well.

As previously mentioned, Tyson had vision. Even with an established and thriving newsstand business, the young entrepreneur wanted more. His next investment was in a theater ticket booking service. Experiencing similar

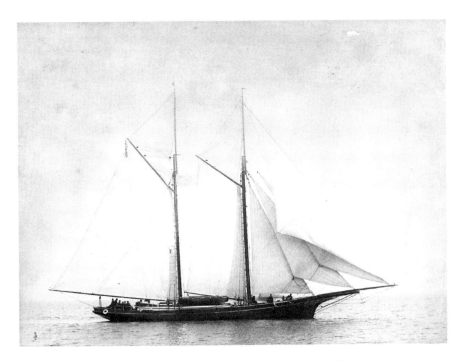

The vessel *Nirvana* during the late 1800s. *Courtesy of the Riverside Yacht Club.*

success as his newspaper delivery business, Tyson merged his two enterprises, calling the new entity the American News Company.

By then, Tyson had achieved a reputation in both the professional world and high society. With the resources to do so, yachting became one of his favorite pastimes, and he quickly earned recognition as being a proficient sailor.

Purchasing a series of vessels over the years—including the well-known schooner, *Nirvana*—Tyson became famous in local circles as being the ultimate waterside host. Extravagant parties, elaborate dinners and unforgettable midsummer events are only a sample of the legendary social gatherings that Tyson and his wife hosted over the years.

Now, back to the club. Although it has not been completely agreed upon, there is a rather believable history to the origin of the Riverside Yacht Club Burgee. The Maltese cross that represents the club presumably came about as a result of the bond between Commodore Tyson and his fellow club member Luke A. Lockwood during their time spent in the service of their country. Apparently, the Maltese cross was a highly respected symbol during the war, and the two veterans felt strongly about including it in their civilian life activities.

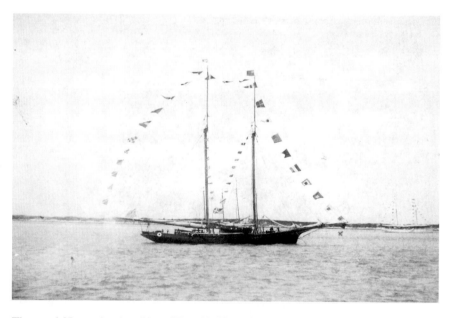

The vessel *Nirvana* dressing ship at Riverside Yacht Club during the late 1800s. *Courtesy of the Riverside Yacht Club.*

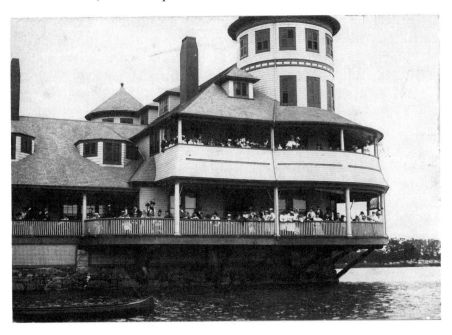

The original Riverside Yacht Club. *Courtesy of the Riverside Yacht Club.*

The original clubhouse, built in 1889, stood on a section of land located near the sea wall and was situated halfway on pilings. The building resembled many of the other Victorian-style structures of the era, with a dining area, a kitchen, a ballroom, reading rooms, card rooms, bedrooms, locker rooms and expansive porches that were trademarks of the popular blueprint.

An article published in the June 29, 1889 edition of the *New York Herald* featured a description of the newly constructed Riverside Yacht Club:

> *The clubhouse has a sort of a story and a half appearance, but is so arranged in regard to the location of its rooms as to afford as much space as is usually found in buildings of much larger proportions. One side, resting upon a substantial granite foundation, fronts on the water and forms a dock. Extending around the other three sides is a very spacious and roomy veranda twelve feet wide with a porte cochère for carriages.*

Shortly after, the *New York Herald* printed an additional story, stating that the site of the Riverside Yacht Club is:

a romantic spot where the waves wash up against one side of it, so that, in very high tides and winds, the spray falls upon the piazzas. A tower, thirty feet in height, is to be constructed over the clubhouse, from the top of which a view of the Sound can be obtained up and down for a great distance.

As nice as the clubhouse was, it was not long before the membership had already outgrown its new facilities. To keep up with the rapidly expanding list of activities, a supplemental section known as the "spar loft" was added in 1893. Included in the construction plans was a billiard room, a shuffleboard area, a bowling alley, housing for the staff and a number of horse sheds. The additions proved to provide ample space to hold the popular Midsummer Balls and Saturday Evening Hops within the new building. Once again, Commodore Tyson provided the funding.

By that time, the membership of the club had grown to include 180 active members, and the fleet boasted ten steam-powered yachts and fifty-two sailboats.

With yachting becoming more and more popular along the local coastline, the Riverside Yacht Club was at the forefront of the newly evolving summer

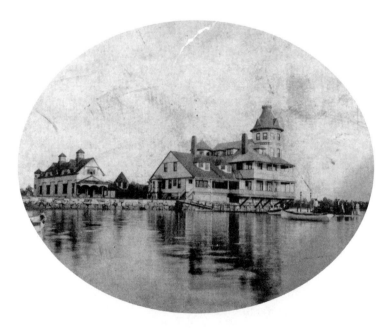

The Riverside Yacht Club in 1894. *Courtesy of the Riverside Yacht Club.*

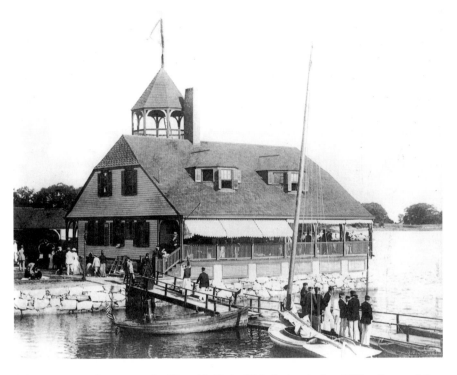

A busy summer afternoon at the Riverside Yacht Club during the late 1800s. *Courtesy of the Riverside Yacht Club.*

pastime. Many people referred to that point in time as the "Golden Decade of Yachting," which essentially lasted from 1890 to 1899.

The original flagship of the Riverside Yacht Club was the magnificent, black-hulled, eighty-three-foot schooner *Nirvana*, owned by Commodore Tyson. The *Nirvana* was designed by naval architect George Steers in 1884. (Steers also drew up the blueprint for the celebrated schooner *America*.)

Long Island Sound hosted some rather elaborate vessels during the late 1800s and early 1900s. Extravagant sails graced the masts and booms of these unique and unforgettable seafaring beauties.

One such yacht was the sailing sloop *Nautilus*. The extensive inventory of mainsheets stored on the *Nautilus* included a mainsail, jib, jib topsail, forestaysail, gaff topsail, flying jib, spinnaker and balloon jib.

With sails becoming more prevalent as regular gear aboard local yachts, there came about what was known as the "skimming dish" sailboat. This particular vessel was designed specifically for carrying a large number of sails, with a substantially small hull area, noticeably wide beams and

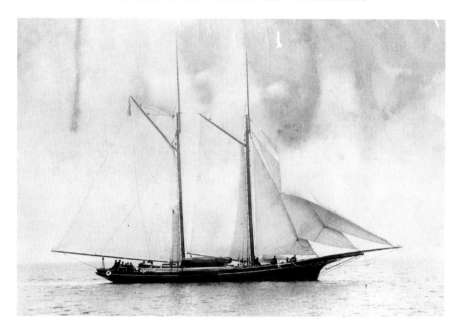

The original flagship of the Riverside Yacht Club, the *Nirvana*, owned by Commodore George Tyson. *Courtesy of the Riverside Yacht Club.*

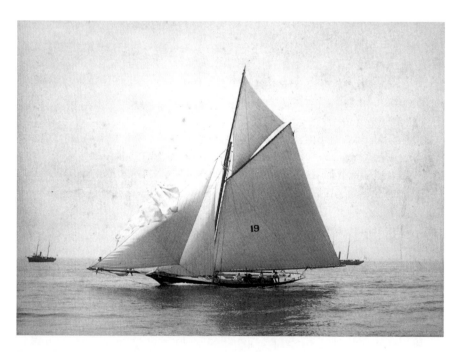

The yacht *Nautilus* sailing in the Riverside Yacht Club Regatta in July 1891. *Courtesy of the Riverside Yacht Club.*

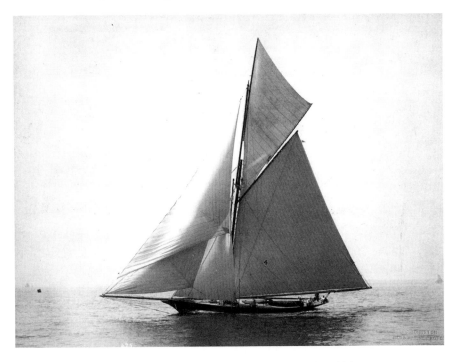

The vessel *Nautilus* during the late 1800s. *Courtesy of the Riverside Yacht Club.*

an extremely deep draft. Long overhangs both fore and aft were another trademark characteristic of this unique vessel.

The first annual regatta at the club was held on July 6, 1889, setting its start line just off Flat Neck Point. Eleven vessels participated in this inaugural event.

The initial Ladies' Day Regatta kicked off on September 2, 1889, with seven yachts competing. The end of September of that year marked the beginning of the annual Pennant Races, entertaining six entries for that competition.

The introduction of the club's annual cruise schedule came about on August 25, 1890. Seven yachts joined in the festivities on that first cruise, including the *Dot*, the *Pearl*, the *Verant*, the *Alcede*, the *Zanth*, the *Doctor* and, of course, the *Nirvana*. The itinerary consisted of stops at Black Rock, New London and Greenport before heading back to Riverside.

With the excitement of the 1895 America's Cup buzzing around the docks, it was to the great delight of the members of the Riverside Yacht Club when it was announced that the impressive steam-powered yacht *Cygnus* had been commissioned for members to view all of the action firsthand.

The Riverside Yacht Club women's team after winning the first race in the Syce Cup series off Rye, New York. *From left to right*: Miss Lois MacIntyre, Mrs. Donald MacIntyre, Miss Charlotte MacIntyre and Miss Kathleen MacIntyre. *Courtesy of the Riverside Yacht Club.*

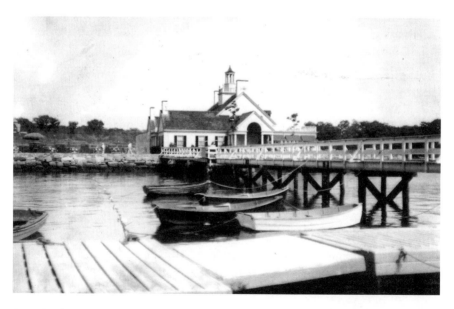

An early picture of the Riverside Yacht Club and pier. *Courtesy of the Riverside Yacht Club.*

When the inception of the Yacht Racing Association of Long Island Sound (YRALIS) was introduced in 1895, there were a number of local and prominent yachtsmen who helped to establish the original foundation. Among them was Riverside Yacht Club member Charles T. Pierce, who was on the committee from 1899 to 1902. Pierce's passion for and contributions to sailing would also lead to achievements as club commodore and, eventually, commodore emeritus.

Other club members who would serve on the board of the YRALIS in ensuing years included Russell J. Nall (1948), James M. Trenary (1952–54), Clifton A. Hipkins (1959–61) and Hamilton G. Ford (1971).

The turn of the century brought with it many changes to the vital and flourishing Riverside Yacht Club. With the unfortunate and emotional passing of founder and first commodore George I. Tyson in 1897, the club membership suddenly found itself without its longstanding leader. Although it was a shock for many and a major hit to the club structure, the loss of the highly revered Tyson made it essential for members to carry on the torch as

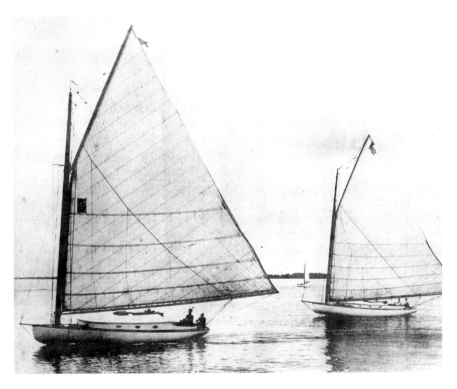

Two catboats cruising on Long Island Sound in 1899. *Courtesy of the Riverside Yacht Club.*

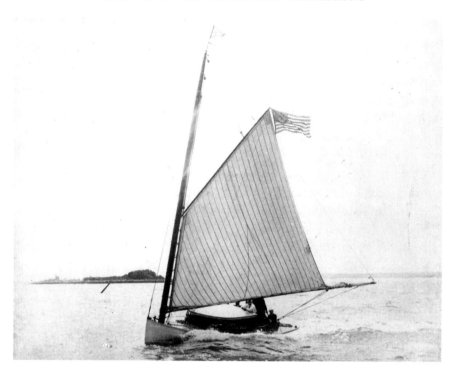

A catboat sailing off the Greenwich shoreline during the 1890s. *Courtesy of the Riverside Yacht Club.*

they knew their original commodore would want them to do. Many of the members were as passionate about the sport of sailing and held an unfailing loyalty to club values. This group included George Tyson (son of the former commodore), Charles T. Pierce, Harry E. Montague and Albert A. Loder.

The club experienced a change in the fleet during the early 1900s, with the larger, more eccentric yachts suddenly disappearing from the local scene. Sadly, even the flagship *Nirvana* was absent from the mooring field, ideally being set aside and dry-docked. What remained was a humble assortment of sloops and catboats.

By 1904, there were 96 active members of the club and thirty-two boats in the fleet—a noticeable drop from the 210 members and fifty-nine boats seen in 1896.

However, this major adjustment period did not deter a healthy core of members from maintaining their enjoyment of all things sailing. Events, regattas and social gatherings continued, albeit on a smaller scale. A committed resolve to uphold Commodore Tyson's initial dream

motivated these men, who were determined to follow in the footsteps laid out for them.

Already struggling, the onset of World War I did not help the efforts of the club's survival. Fortunately, it was somehow able to sustain itself until the war finally came to an end. With new energy, boats began to return to the local shoreline, and members once again joined in club activities. People were able to enjoy life once more, and they took advantage of every moment.

Things continued on an upswing well into the era known as the Roaring Twenties, and the club saw a refreshing increase in boating activity and races. Club regattas were complemented by an ever-growing schedule of interclub events with a growing number of other yacht clubs all over Long Island Sound.

As part of the changing times, the style of sailing itself was also entering a new era. For instance, the old gaff-rigged boats were suddenly being replaced with the jib rig (or Marconi rig), and expansive spinnaker sails were popping up more frequently on the horizon. The international sailing scene was beginning to influence American boating, with Sweden introducing the Genoa jib to local waters.

The first club regatta after the war ended was held on August 13, 1922, and proved to be a huge success. A variety of catboats, sloops and dories all met at the start line off Flat Neck Point as they anticipated an exciting two-and-a- half-mile race to the finish. The following weekend entertained a five-and-a-half-mile event for the same group of enthusiastic sailors.

A Ladies' Race and the first-ever Handicap Class event were additional highlights to the season.

It was about this time that the one-design racing sloops began springing up all around Long Island Sound. This uniquely designed sailing vessel was approximately thirty feet in length and typically hosted three to four crew members on board.

There are several local towns that claim boasting rights to having the first one-designs in Connecticut. Without presuming who was correct—and, by all rights, there may be more than one that shares that honor—there are a few blueprints that clearly were there at the onset of this new era of sailing. They include the Herreshoff "S" Class, the Victory Class and the Sound Interclubs. Interestingly, whereas Norwalk and Rowayton quickly jumped on the bandwagon, the Riverside Yacht Club instead opted to study and learn before leaping head first into the latest waterside rage. However, once it decided it liked the looks of things, it gravitated toward the Wee Scots, Lightnings and, eventually, the very successful Riverside dinghies.

Riverside Yacht Club

RIVERSIDE, CONNECTICUT

MENU - 1924

A LA CARTE TO ORDER

HORS D'OEUVRES

Clams35	Fruit Cocktail50	Stuffed Celery40
Lobster Cocktail90	Celery25	Canape of Anchovies...... .60
Shrimp Cocktail65	Olives25	Thon a l'Huile50
Crab Meat Cocktail....... .75	Tomato Surprise35	Mackerel in White Wine... .50

SOUPS

Chicken Okra30	Mock Turtle40	Puree Split Pea25
Cream of Tomato......... .30	Chicken Gumbo30	Cold Consomee25

SEA FOOD

Broiled Lobster $1.25 up	Sea Bass Saute Meniere................. .65
Filet of Sole Tartar.................... .65	Scallops with Bacon.................... .75

EGGS

Boiled30	Scrambled Eggs60
Fried "35	Scrambled " with Bacon75
Poached40	Eggs Benedict75
Ham or Bacon and Eggs................ .75	Eggs R. Y. C........................... .65

STEAKS — CHOPS

Veal Cutlet with Fried Egg.............. .90	Lamb Chop50
Minced Tenderloin of Beef, Chausseur.....1.00	Mutton Chop55
Minute Steak1.25	English Mutton Chop1.00
Small Steak1.30	Chicken in Casserole a la R. Y. C., for two..3.50
Tenderloin1.45	Breast of Chicken Mascotte............1.50

POTATOES AND VEGETABLES

Saute Potatoes25	Fried Egg Plant.......... .35	Cauliflower Hollandaise.... .60
Lyonnaise Potatoes........ .30	Boiled Rice20	French Flageolets40
Fried Sweet Potatoes...... .30	Mushrooms on Toast...... .75	New Asparagus, Hollandaise
Hashed Brown Potatoes... .25	French String Beans...... .40	or Brown Butter.......... .60
French Peas40	Sprouts45	

SALADS

Beet30	Lettuce35	Cauliflower60
Tomato35	Vegetable75	Salad a la R. Y. C......... .50

PASTRY AND ICE CREAM

Old Fashioned Strawberry	Vanilla Ice Cream........ .25	Biscuit Tortoni35
Short Cake with Cream.. .40	Chocolate Ice Cream...... .25	Merinque Glace35
Apple Pie, .20; a la mode.. .35	Parfaite Panache.......... .45	

CHEESE

Cream25	Swiss30	Port du Salut30
American25	Roquefort50	Camembert30

Pot of Tea, .25; Cup....... .15	Pot of Coffee, .25; cup..... .15	Iced Tea or Coffee........ .25

Bread and Butter........................ .10

A. CONSTANTIN, *Manager*

The Riverside Yacht Club menu in 1924. *Courtesy of the Riverside Yacht Club.*

There came a new and energetic interest in the sport of ocean racing during the mid-1920s and early 1930s. This time around, the vessels seen competing on the international circuit were a bit smaller than those during the turn of the century. Although not completely embraced by the club as a

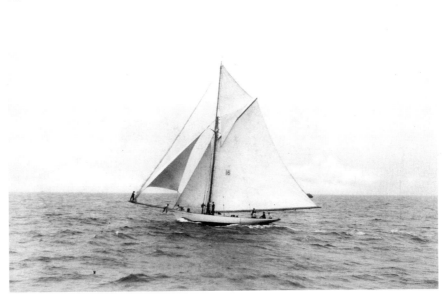

The Riverside Yacht Club vessel *Chispa* competing in the American Yacht Club Regatta on June 17, 1890. *Courtesy of the Riverside Yacht Club.*

whole at the beginning, there were a handful of hard-core sailors from the Riverside docks that competed enthusiastically from 1923 to 1930, among them Gordon Raymond aboard *Bagheera* (1923) and *Cutter Viking* (1930), Elon Foster aboard *Damaris* (1923) and *Northern Light* (1924), Thomas Floyd-Jones aboard *Alamyth* (1928) and *Fame* (1930) and Anthony Anable aboard *Sais Pas* (1930).

In 1928, the membership realized that perhaps the clubhouse needed some updating. With finances in good order, the idea to draw up a new blueprint and begin construction went forward without any major problems. Working on an efficient schedule, the opening ceremony for the new clubhouse was held in May 1929. Thankfully, the clubhouse project was completed before the onset of the Great Depression, which occurred just a few months later.

Along with all of the other area yacht clubs, the membership knew that it needed to make a plan in order to keep its doors open during the financial hardship that had suddenly swept the country. It decided to cut back on many events and limit the hours of operation. With an already stable financial situation before the crash hit, the Riverside Yacht Club found itself

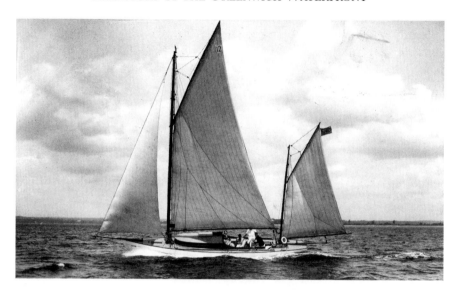

The Riverside Yacht Club vessel *Nancy Jane* during the Overnight Race to Stratford Shoals in July 1931. *Courtesy of the Riverside Yacht Club.*

somewhat better off than many other clubs. With that comfort zone and some wise choices of where to cut costs, the Riverside Yacht Club was able to successfully weather the economic storm.

The first running of the Riverside-Stratford Shoal Overnight Race made its appearance on July 1, 1931. With the start gun going off at ten thirty in the evening that year, nineteen competitors set out on a forty-five-mile course that would take them from Flat Neck Point to the Stratford Shoal Lighthouse and then back to Greenwich. Crossing the finish line first at the inaugural affair was the *Narwahl*, from the City Island Yacht Club, arriving in Greenwich at 9:52 a.m. the following morning.

The 1932 event saw the *Tinivere* of the Indian Harbor Yacht Club taking first place. The yacht *Tidal Wave* from the Larchmont Yacht Club earned the blue ribbon in 1933.

The introduction of the annual Stag Cruise came about around 1930–31 and was designed as a men-only event held toward the end of the sailing season. A formal Riverside Yacht Club Race Committee was created in the 1930s. Toward the end of the decade, Russell Nall from Riverside and William H. Taylor (associate editor of *Yachting* magazine) would make local sailing history by publishing the first *Race Committee Handbook*. This new manual would change all of competitive sailing on Long Island Sound.

One of the more notable vessels in the Riverside Yacht Club fleet was, unarguably, the Riverside dinghy. Announcing its arrival in 1934, it was not until two years later, in 1936, that its popularity really took off. During that year, sixty to seventy dinghies could be seen at any given time along the Riverside shorefront. Fenwick Williams from Riverside played a key role in the design of this new and exciting vessel. George Lauder of Greenwich constructed the original fleet. With orders too big for one man to fill, the Fairfield Boat Works of Greenwich ultimately took over production. Philippine mahogany and Everdur fasteners were trademark materials used in the construction. Once completed, the little boat topped out at eleven feet, five inches and boasted a four- foot, six-inch beam. A sliding gunter rig provided the basic means of power. Junior sailors, female sailors and senior sailors all greatly enjoyed cruising aboard the Riverside dinghies. For nearly a quarter of a century, this humble sailboat earned a spot at the top of the list at Riverside.

Following in the footsteps of the Riverside dinghies were the Lightnings. R.J. Nall and Carroll Belknap are given credit for bringing this latest one-design class to the local shoreline. Designed by Sparkman and Stephens

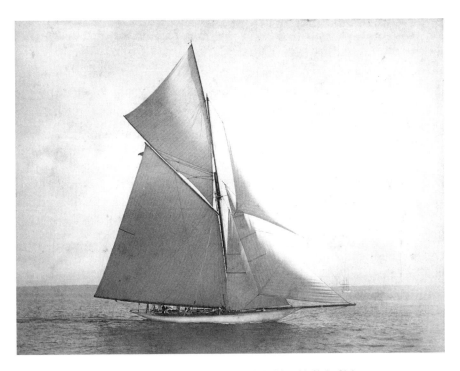

The vessel *Gloriana* during the late 1800s. *Courtesy of the Riverside Yacht Club.*

and constructed by the Skaneateles Boat Company, the Lightnings were centerboard sloops that sailed smoothly with even the slightest of wind. Their popularity grew quickly, and in 1940, the Riverside Yacht Club hosted the second Lightning Class Championship Series. Club member Ted Maher brought home the gold medal at the event in 1944. Fellow members James M. Trenary and Hamilton G. Ford would accept the position of National Lightning Class Association president in ensuing years.

With the junior yachtsmen and yachtswomen of the club getting more involved in the sport of sailing, member George A. Round decided that it was due time for them to have their own official program. The Junior Sailing Program was formally introduced in 1936 and was fully up and running the following year. The program has experienced great success ever since.

One of the most devastating hurricanes to ever hit the Connecticut coastline occurred on September 21, 1938. Known as the Long Island Express, strong winds, heavy rains and exceptionally high tides caused major destruction up and down the entire New England shoreline. Amazingly, most of the yachts in the Riverside Yacht Club fleet were, for the most part, safe from extreme damage. However, the clubhouse and grounds were another story. Two and a half feet of water filled the clubhouse, and the Junior Clubhouse was completely lifted off its foundation. It is hard to believe that just a day after the storm had passed, members were enjoying dinner in the club dining room. This was entirely due to a monumental effort by the entire membership to clean up the mess. Since there was no power supply after the hurricane, the members brought out candles by which to eat.

Lois McIntyre, a product of the Junior Sailing Program, won both the Syce Cup and the Adams Cup in 1940, bringing a great amount of respect and prestige to the Riverside Yacht Club. Coming from a family that had collected many trophies over the years, McIntyre had clearly inherited the sailing gene. In addition to her on-water skills, McIntyre was also a talented artist. She was so gifted, in fact, that one of her watercolors depicting a commissioning ceremony at the club appeared on the cover of the June 1947 edition of *Yachting* magazine.

With another world war imminent, it was time, once again, to batten down the hatches and prepare to weather yet one more financial challenge. Using the same foresight and creative management that had helped the club survive the First World War, Riverside was able to successfully maintain operation through the second.

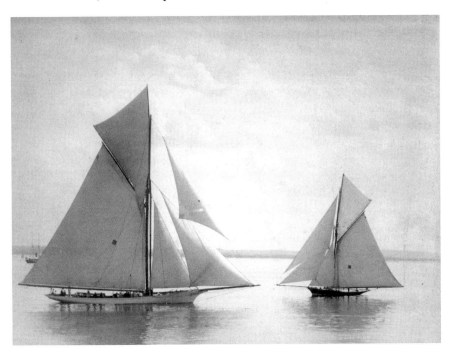

The yacht *Shamrock* competing in the New York Yacht Club regatta on June 19, 1890. *Courtesy of the Riverside Yacht Club.*

As if dealing with the effects of the war were not enough, another destructive hurricane struck the local shoreline on September 15 and 16, 1944. This time, it was the mooring field that suffered the greatest damage, while the clubhouse escaped relatively unscathed.

With World War II finally coming to an end, the club membership was able to come up for air and get back to life as usual. The club began staying open during the winter that same year, and the first of many Sailors' Evenings joined the list of regular events. Sailors' Evenings were devoted to cold winter nights, sitting comfortably and warm in the clubhouse and listening to tall tales of the sea shared by members and fellow yachtsmen. A few of the more notable speakers were Bob Bavier sailing aboard the *Constellation*, George O'Day sailing aboard the *Vim* and the *Nefertiti*, former commodore Bob McCullough sailing aboard the *Valiant* and the *Constellation*, John Biddle and Norrie Hoyt (both Ocean Racing veterans), Ed Raymond and Lee Van Gemaert (both prominent sailmakers), Frank Capers IV and Wright Britton (both proficient long-distance cruisers) and George and Bethany Schuster, who navigated some twenty thousand miles in their retirement years.

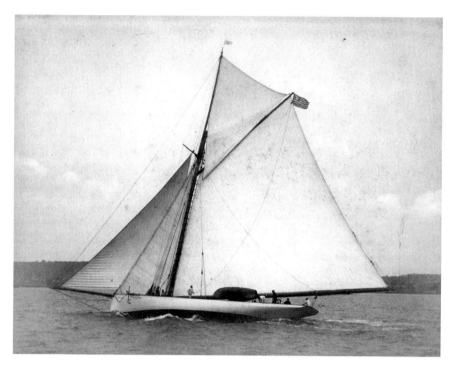

The vessel *Titania* during the late 1800s. *Courtesy of the Riverside Yacht Club.*

The sport of frostbiting saw its start along the Riverside waterfront during the winter of 1946–47, although the Manhasset Bay Yacht Club and a handful of other clubs around Long Island Sound had already been participating in cold-weather sails since 1932. The Riverside dinghies were the vessel of choice back then but were eventually replaced by the Fiberglas Dyer dinghies. Next to join the winter fleet were the Sunfish. A twenty-week schedule kept the hard-core Riverside Yacht Club sailors busy every Sunday from November to April.

The Riverside Yacht Club has continued to grow and prosper every year since its inception. Although the membership has changed with the times, the honoring of tradition remains its foundation.

7

THE INDIAN HARBOR
YACHT CLUB

The Indian Harbor Yacht Club was initially founded in New York City in July 1889 and officially incorporated in the state of New York on April 11, 1892. The original membership included John Muller, Edward B. Brach, D. Malcolm Winne, Frank Bowne Jones and Henry E. Doremus. The trustees were Morton F. Plant, Elbert A. Silleck, Richard Outwater and Francis Burritt. Of that entire cast, only Silleck and Outwater were residents of Greenwich.

At first, the site of the clubhouse was set up on Finch's (or Tweed's) Island in Greenwich, since most of the members traveled via boat from New York City. It stayed at that location from 1892 to 1895, at which point E.C. Benedict acquired the land. Once Benedict arrived, members sent the following letter to the island's new owner:

It is understood between Mr. E.C. Benedict and the Board of Trustees of the Indian Harbor Yacht Club that the club may retain possession of Finch's Island for its use as a Club Station for the yachting season of 1895, say, until about 1ˢᵗ October, on the same terms as the Club has heretofore paid for the use of those premises, namely, at a rental of $50 quarterly, payable in advance, the first payment to be made on 1ˢᵗ May, 1895 it being understood, however, that Mr. Benedict has the right to put up range lights on the island, or do such other things as he may wish as will not cause inconvenience to the Club, and it is further understood that should Mr. Benedict, any time before 1ˢᵗ October, 1895, dredge about or around

*the Island and use the premises for dumping purposes, thereby in the opinion
of the Trustees, rendering the Island useless as a Club Station, the Trustees
shall notify Mr. Benedict and the proportion of rent for the unexpired period
shall then be refunded to the Club.*

Mr. Benedict never responded to the letter or to any further attempts by the
club committee to reach him to confirm the proposal. Eventually, the committee
pursued other options, ideally obtaining property at Rocky Neck Point. At the
annual meeting on January 8, 1896, the trustee report read as follows: "Owing
to the sale of Finch's Island, the club vacated at the close of the last yachting
season, the station which it had occupied there for the last three years."

The report went on to say that the new site of the club would be at Rocky
Neck Point. It added, "This change will be greatly to the advantage of the
members and will enable the club to extend the best facilities to its members."

Although they believed that the lease was accepted by all parties, the
Rocky Neck Point locale also fell through. The next opportunity for a club

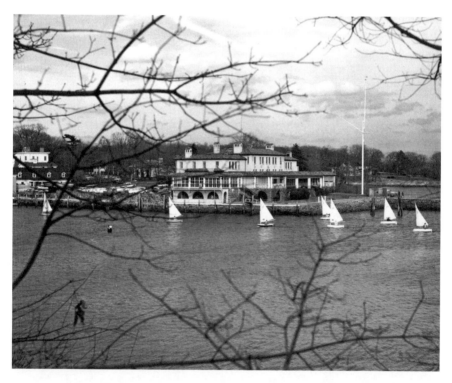

Sailing off the Indian Harbor Yacht Club. *Courtesy of the Greenwich Library.*

site was said to have been at 675 Steamboat Road, opposite the old Silleck House. However, at a club meeting on July 14, 1896, it was suggested to lease a property at Commodore Wills's Belle Haven estate for the year May 1, 1897, to May 1, 1898.

In 1893, the club membership was 172 (27 of whom were actually from Greenwich). The fleet consisted of seven schooners (45 to 98 feet); thirty-seven sloops, cutters and yawls (22 to 102 feet); twenty-seven catboats (18 to 34 feet); and fourteen steam and naptha vessels (25 to 90 feet).

By 1897, the membership had grown to 287. The fleet boasted seven schooners (60 to 88 feet); thirty-two sloops, cutters and yawls (23 to 65 feet); twenty-one catboats (26 to 38 feet); twenty-seven steam yachts and launches (17 to 138 feet); and a variety of one-design dories.

The first club yearbook was created in 1897 and included such information as proper salutes for "foreign clubs" (those from outside the New York, Long Island Sound and Rhode Island waters).

The first official meeting in the new clubhouse was held on June 19, 1897. The *Greenwich Graphic* described the building as "cozy, pretty, picturesque, convenient and with unsurpassed facilities."

The architectural blueprint called for a three-story structure with rich cedar shingles, white trim and ceilings that boasted Georgia pine. The main room was forty-two feet by twenty-nine feet and had a tiled fireplace and stairs—also made of Georgia pine—leading to the second floor.

The second level comprised storage areas, a kitchen, a pantry, a café, restrooms, coatrooms, ten bedrooms, a ladies' dressing room and an outside balcony that offered fabulous views of Long Island Sound.

The club membership greatly enjoyed putting on gala affairs. Flowers, bunting, lanterns and flags were just a few of the aesthetics that regularly decorated the extravagant dinners, cocktail hours and late-night dances.

A full-time steward to keep watch over the club property was presented in 1897.

During a special meeting held in 1898 at the Manhattan Hotel in New York City, the introduction of an open knockabout class for the club was announced. The issue of enlarging the clubhouse, although it was only a year old, was also brought up. The proposed renovations included a new grill room with an adjoining café area, a formal dining room, additional storage rooms, a larger piazza, and a 278-foot-long stone jetty to be constructed on the west side of the club property.

The Indian Harbor Yacht Club was officially incorporated in the state of Connecticut on December 7, 1901.

There were an abundance of impressive steam-powered yachts in Greenwich and all along Long Island Sound during the early 1900s, adding a great allure to the local boating scene. One of these great yachts was the *Endymion*, owned by Commodore George Lauder Jr. The *Endymion* was a magnificent schooner-rigged vessel that boasted specifications of 137 feet in length; a 24-foot, 6-inch beam; a 14-foot draft; and a 116-ton gross weight. It was designed by Clinton Crane and built in 1899 by George Lawley & Son from Boston.

Commodore Lawley entered the *Endymion* in the 1905 Kaiser's Cup Race, which took skippers over a three-thousand-mile course running from Sandy Hook to the Lizard in England. During the crossing, the *Endymion* averaged 9.66 knots and crossed the finish line "across the pond" in third place.

The club sponsored a class of one-design catboats designed by Morgan Barney from about 1905 to 1907. These vessels were shoal-draft boats, with a ballast of 450 pounds and constructed with the finest fastenings, brass and mahogany finishes, oak frames and cedar planking. They also boasted a 350-square-foot sail area.

Women made a notable impression at the club in 1907, when the bylaws were amended to include flag membership. The amendment read as follows:

Any woman owning a yacht is eligible for election to the club as a flag member, and shall, upon election, pay an annual subscription of $25, but no initiation fee. Such membership shall continue only during the period of yacht ownership, and carries only the following privileges: the right to fly the club burgee, to have private signal registered with the secretary, to enter yacht in club races, to have use of the club floats.

The years 1907 to 1909 were financially challenging for the Indian Harbor Yacht Club. It was a time when the club wisely opted to tighten its belt and come up with creative ways to save money without losing members.

Year-round access to the club was initiated in 1909. The annual report for that year was the first that spoke of the official purchase of the club property from Commodore Wills.

As the twenty-fifth anniversary of the club approached in 1911, the fleet roster rivaled some of the best. Of course, the *Endymion* was on the list, escorted by such classic beauties as the 264-foot *Erin* owned by Sir

Thomas Lipton; the 245-foot *Wakiwa-H* skippered by L.V. Harkness; the 305-foot *Iolanda* captained by Morton Plant; and the 138-foot *Oneida II* owned by E.C. Benedict.

Swimming and diving competitions were popular at the club, along with canoe and tub races. At the 1913 annual water sports event, nearly eighty prizes were awarded to the large field of competitors.

When World War I began, the *Erin* had the honor of escorting the America's Cup challenger *Shamrock IV* back to the United States.

The club hosted a Cup Defender Class race on June 23, 1914. The highly celebrated *Resolute*, *Vanitie* and *Reliance* participated in the exciting and unique event. The ultimate victor was the *Resolute* as the three boats made history appearing together for the first time. During the event, the club provided the use of the *Ursula*, a 175-person-capacity steamboat, to watch the memorable competition.

During the war, the club once again had to keep a close eye on the budget. With many members and fleet boats being lost to the war efforts, it became extremely difficult to stay afloat. After surviving the duration of the war, it was agreed at a meeting held on November 11, 1918, that "the members in the Army, Navy, or Marine Corps, on their return to civil life have their dues pro-rated from the date of their discharge from service."

That meeting also proposed for a bathing beach on the club property to be constructed.

The club celebrated its thirtieth anniversary by bringing in 163 new members, making the grand total to date 340. The fleet at that time included eight steamers (131 feet to 256 feet), fifteen schooners and yawls (up to 185 feet) and twenty-seven sloops (up to 74 feet).

By 1919, the war had ended, and life at the Indian Harbor Yacht Club picked up its pace in a grand way. Unfortunately, on October 2, 1919, the club was completely destroyed in a devastating fire. Bennett Fisher, a young boy at the time who had watched it all happened, simply exclaimed, "It just went down in a heap!"

An article in the *Greenwich Graphic and News* on October 3, 1919, described the tragic event as follows:

> *The Indian Harbor Yacht Club was completely destroyed by fire at an early hour yesterday morning, entailing a loss estimated at nearly 100 thousand dollars. The building was insured for 30 thousand. Many valuables, furnishings, all trophies, maps, models, pictures, and all records were among*

the ruins. There were twelve guests, some from New York, on the second floor, while the help occupied rooms on the third floor. All lost their clothing, personal effects and money. The employees of the club, all of whom were asleep in the building at the time, were: William O. Dolan, steward; Anjo Gaibert, waiter; Miss Margaret Doll, housekeeper; Harry Doll, her husband, a dishwasher; R.H. Clark, chef; Charles Urban, fireman; and George Famile, clerk. Some of the guests and servants were trapped in their rooms and were taken down scaling ladders to places of safety. Mr. Dolan, who occupied a room over the place where the fire was discovered, detected the odor of smoke and aroused the employees. He then found the basement under the front porch to be on fire and flames surrounding the building. The Amogerone and Volunteer fire company responded to the alarm. Lines of hose were laid and water was pumped from the Greenwich Harbor. The firemen fought the blaze for fully 4 to 6 hours. All that remains of the building is a small wing about 15' square. A strong southeast wind was blowing at the time which carried the sparks and put the Miller house, a fashionable summer hotel, and other residences in the vicinity of danger. The garage on the club grounds about 200' distant and a flag pole 30' from the Club House were undamaged. As the Club went out of commission for the season officially this Wednesday, some of the employees had left. A member of the Club said yesterday that plans would probably be made soon for another building on the same site. He said the old building was started by Joseph P. Crowley in 1896 with the construction of the main portion. Extensive alterations were made in the building only last year which cost about $15,000. The Club has been in existence 30 years. It has a membership of about 400 at the present time.

Indeed, the wheels were almost immediately set in motion to build a new clubhouse. A "Notice of Special Meeting" was sent out on October 18, 1919:

To the Members:

Since the destruction of the Club House by fire, the Board of Directors have been giving serious consideration to the various problems which have confronted them, and especially to the size and type of house which should be built.

It is their opinion that immediate preparation be made for the erection of a modest and well equipped Club House.

It is, therefore, decided to call a special meeting of the members to be held at Pickwick Inn on Friday evening, October 24th, at 8:30 o'clock, for the purpose:

First: To pass on the size and type of Club House to be erected.

Second: To consider and act upon the form of security to be issued to members subscribing to the Building Fund.

Third: To act upon a Resolution limiting the membership of the Club.

By order of the Board of Directors.
Ralph S. Slaven, Secretary

With the new clubhouse scheduled to open on Memorial Day 1921, 1920 was a year of construction, which included not only the new clubhouse but also a retaining wall on the west side of the club grounds. The retaining wall was intended to compensate for the "lifting" of the clubhouse to a higher location and also to create an extension of the beach area.

Between July 27 and August 4, 1920, the Boston Yacht Club made a formal challenge to the Indian Harbor Yacht Club to compete in the Manhasset Bay Challenge Cup. The club defended its Manhasset Cup honors on September 15, 16 and 17—and won. The yacht *Wasaka* sailed as the victor for the club, with the *Nahma* (the previous years' winner) competing as well. Both yachts were considered to be the fastest boats in their class on the Atlantic coast and were designed by club member Captain Addison Hanan.

At a meeting in December 1920, it was announced that the club had challenged the Corinthian Yacht Club of Marblehead for the Greenwich Cup. Years earlier, the Corinthian Yacht Club had secured the cup, and the members of the Indian Harbor Yacht Club thought it was about time they brought it back to Greenwich. The races were held on August 18, 19 and 20 off Marblehead, and the Indian Harbor Yacht Club was successful in earning the rights to the coveted cup, thanks to Captain Addison Hanon's "R" boat *Ariel*, which he designed and built just for this competition.

Members Clifford D. Mallory, Richard A. Monks, Addison D. Hanan and Frank Jones were selected to represent the Indian Harbor Yacht Club in the Yacht Racing Association of Long Island Sound (YRALIS) in 1920.

In a report given by Commodore Smyth on March 14, 1921, it was learned that Smyth had ordered a large brass medallion depicting the Indian Head (the official insignia of the club) to be placed in the floor of the club

porch as a gift. Also to be added to the front porch ambiance shortly after was a spyglass generously donated by Mrs. C.T. Wills.

The 1921 season proved to be a successful one for the Indian Harbor Yacht Club. The members brought home many trophies, the new clubhouse was well received and the atmosphere waterside was filled with positive energy.

Ocean racing once again found a place at the Indian Harbor Yacht Club in 1923. The Bermuda Race, which had not been held for nearly fourteen years, was finally back on the event calendar.

The boathouse was brought back into service on April 30, 1924, in the hopes of generating more interest in small boat sailing by the junior members of the club. This marked the beginning of junior sailing as a whole along Long Island Sound, with a handful of other clubs initiating programs of their own.

Holt Willard was commissioned to run the new junior program, and many of the Indian Harbor one-design boats were made available toward the effort. The basics of sailing, seamanship and navigation were taught to the young skippers by Willard. The first boat to compete from the Indian Harbor Yacht Club junior program was entered at the Junior Championship races hosted by the Seawanhaka Corinthian Yacht Club in Oyster Bay, Long Island. Bennett Fisher became the first Junior Yacht Club commodore, with Margaret Mallory taking the position of vice-commodore.

The first win by a junior sailor at Indian Harbor was earned by the son of Commodore George Lauder Jr., also named George. The event was the Junior Sailing Class Championship.

With a strong inaugural junior sailing year under its belt, the club spared no cost in keeping the ball rolling. Joining Willard on staff was Maurice Dodge, an undergraduate at Yale University. Many of the members generously offered the use of their boats as practice vessels for the up-and-coming generation of skippers.

One of the first girls to participate in the program was Lorna Whittelsey. She proved to be quite a natural sailor, winning the 1927 National Women's Sailing Championship, with the sister team of Edith and Helen Wills as her talented crew. During an eight-year period of competing in that event with a variety of crew members, Whittelsey's boat earned the blue ribbon an amazing five times.

For the first time ever, a female was invited to participate in the Larchmont Race Week, and that was, of course, Lorna Whittelsey. She sailed aboard

Gerald Lambert's yacht *Vanitie*. Whittelsey was also the first young woman to crew in the Bermuda Race. That was in 1934 aboard the *Stormy Weather*.

The 1920s proved to be a decade of great successes, both recreationally and professionally. Profits came easier, stresses were fewer and life, in general, had a more laid-back feel to it.

As a result, some of the most magnificent vessels of that era began visiting Greenwich Harbor on a regular basis. A few of the more notable yachts included the *Southern Cross*, owned by Howard Hughes; the *Hussar*, owned by E.F. Hutton; the *Hi-Esmaro*, owned by H. Edwin Manville; the *Sea Cloud*, owned by Marjorie Post Davies; the *Migrant*, owned by Carl Tucker; the *Aras*, owned by Hugh Chisholm; and the *Aloha*, owned by Arthur Curtis James.

Clifford Day Mallory Sr. was elected commodore in 1930 and stayed on in that capacity until 1936. Mallory was the owner of the twelve-meter flagship *Tycoon* and was a rather accomplished and respected sailor. One of his victories came at the 1930 One-Design Twelve-Meter Class Championship aboard the *Tycoon*. Mallory also played an influential role in the introduction of the ten-meter class, as well as the North American Yacht Racing Union.

Although life on the water was thriving, 1930 also saw many member resignations as a direct result of the Great Depression. Even though it was a great financial struggle to maintain business as usual, the club still found a way to keep a number of the scheduled events going, such as the Forty-fourth Annual Regatta, the Autumn Regatta, the local competitions for the Law Cup, two of the races for the Atlantic and Inter-Club Classes and a number of junior sailing events. The club was even able to find the funds to build six boats for its new Snipe Class.

In the club's continuing effort to be creative with how and where it would spend and save money, it was decided to temporarily shut down the formal dining room and use the grill room for serving meals, close off the housing accommodations for the time being, utilize only certain areas of the clubhouse for events and lower the cost of the annual dues while times were tough for the members who were, thus far, still hanging on.

Things began to look a little better by 1934, an indication being the record number of eighty-eight young skippers enrolled in the junior sailing program that season.

The following year, many of the members stepped up to assist with some of the costs of operation out of their own pockets. Among them were Commodore Mallory, who covered the construction of a new taproom; John Maher, who made much-needed repairs to the dance floor free of charge;

J. Burr Bartram, who donated a new marquee; H.R. Kunhardt Jr., who made renovations to the ladies' dressing room and provided some updated furniture; Mrs. George Townsend, who brought new screens; George Lauder, who put on a fresh coat of paint, replaced the lights and gave money to the launch service; Mrs. Hugh Chisholm, who provided new slipcovers for the main lounge, metal plant holders for the new taproom and a piano to be used for dances; and Mr. Mallory, Mr. Page and Mr. Lauder, who all donated sails for the new Snipe Class fleet.

Every year seemed to show great improvements, and by 1937, activities at the club, both on the water and on land, were filled with new energy and new life.

Although everything appeared to be back at a peak, by 1939, things greatly changed with the announcement of World War II. The membership, once again, experienced a decline. Even so, the remaining yachtsmen and yachtswomen were not ready to give up the ship just yet. Previous commitments continued as scheduled, although many had to ultimately be cancelled due to new developments in the war effort.

Even amidst all the havoc, the club was still able to introduce its latest award, called the Forstmann Trophy, which was designed for the weekend sailors. That year, Rowe Metcalf kindly provided replicas of the Metcalf Trophy for the winners of individual regattas.

Trying to maintain somewhat of a normal club life as best it could, it was agreed that Zalmon G. Simmons Jr. should represent the Indian Harbor Yacht Club in the American Power Boat Association Gold Cup competition. As hoped, Simmons did, indeed, earn the blue ribbon, crossing the finish line first in his boat, *My Sin*.

Upholding their reputation for being a strong yachting community, members once again contributed either their own money or their time in helping to keep things up and running at the club while the war continued.

A fin keel, twenty-four-foot fractional sloop rig known as the Lawley 110 Class was introduced to the local sailing scene in 1940. Designed by C. Raymond Hunt, it quickly gained in popularity through an aggressive promotional effort by the club. The juniors, also, were making great strides forward that year.

Commodore Kunhardt and Rear Commodore Sears made sure that the 1941 annual cruise remained on the calendar by generously offering $1,000 each to help with the cost of sponsoring the event. Sears and several of his fellow members paid out of pocket for the three-day spring regatta to be held on July 5, 6 and 7 as planned.

That same season, Commodore Kunhardt bought a Pirate sloop specifically for the junior sailing program.

The club lost Commodore Bartram to the U.S. Navy and the war effort in 1942, with his resignation being announced on May 29. Clarence Young stepped in to fill the commodore's position.

Along with Bartram, other members who enlisted in the service included vice-commodore Oliver Redfield, Rear Commodore Rowe Metcalf and Secretary W.R. Gherardi Jr. For those who stayed stateside, an unofficial water patrol was formed amongst area yachtsmen. Using their vessels' sonar listening equipment, they would regularly cruise the waters of Long Island Sound. If they detected unusual activity, they would contact the local authorities or the Coast Guard. Two of these watch vessels, the *Mystic* and the *Bonnie Dundee*, belonged to Philip and Clifford Mallory.

Eventually, the Greenwich Harbor Patrol was formally founded, and many club members participated full time in the local waterfront protection plan.

The regatta held on July 12, 1941, turned out to be quite successful, with a healthy fleet of ninety-two yachts showing up to the event. The Atlantic Class National Championship was held on August 25, 26 and 27 just off the club property. The junior sailing program was actually able to show a profit, and Fleet Captain Mills Husted was credited with providing the much-needed enthusiasm and support that the young skippers used to their favor.

All-night sailing and cruising on Long Island Sound was curtailed for the time being, per order of the U.S. Navy. The Coast Guard gave permission for yachts to sail three evenings a week by June 1944; however, there was a restricted area where no vessels were allowed—for any reason—that ran through the middle of Long Island Sound. The only way to pass through would be to be fingerprinted and approved.

Finally, at the annual meeting in December 1945, it was announced that there appeared to be an end in sight. When the war was officially over, life along the waterfront quickly resumed its prewar status. In addition to the regular scheduled events, the thus far slow-moving winter frostbiting program began to experience a whole new level of interest. (An interesting side note is that George Lauder decided to christen his particular frostbiting contender the *Charaachoggagogmonchoggagagonamog*, which presumably translates to "Little Squid." That's a lot of letters to put on a ten-foot dinghy.)

The year 1946 marked a great growth period for the Indian Harbor Yacht Club. The war was over, and everyone was, once again, able to find some

financial stability. The energy and enthusiasm along the waterfront was slowly returning, and the racing schedule was steadily increasing. Both the junior and senior members were giving a lot of attention to building the future of the club, and those who were able continued to offer their financial support. A beautiful brass cannon was donated by Vice-Commodore Warren; an impressive eight- by twelve-foot American flag to be displayed on the club flagpole was given by A.D. Brixey Jr.; and a one-of-a-kind L-16 sailing model was offered as the Season Championship Trophy by A.E. Luders.

The juniors welcomed yet another new class of boat, the Arrow, to their ever-growing fleet. Designed by the Knudson Yard in Huntington, Long Island, each Arrow boasted a name that reflected a different Indian tribe. The vessels were easy to handle, stable in most weather conditions and fun to sail. Plus, since the club itself was known as "Indian Harbor," the next generation of captains felt a strong connection to this new class of boats.

Today, the Indian Harbor Yacht Club retains its prestigious reputation and boasts an active racing schedule for all classes of sailors.

8

THE BELLE HAVEN CLUB

As part of the development of the Belle Haven area of Greenwich, the plan was to establish a club, of sorts, that would attract a variety of members to the picturesque shoreline. The Greenwich Casino Association was to be its name, and it was officially founded on June 14, 1889, by George P. Sheldon, William J. Mead, James McCutcheon, H.W.R. Hoyt, John D. Barrett, Leander P. Jones, Henry B. Riggs, George W. Ely, Edward H. Johnson, Edward K. Willard and Joseph Milbank on behalf of the Belle Haven Land Company. (An interesting note is that the word "casino" at that time was defined as "a place for meetings, entertainment, dancing, etc.," not gambling.)

The original goal of the club was rather broad and ambitious, stating that the company was

> *authorized and empowered to purchase, hold, build upon and improve, lease, mortgage, sell, grant and convey real estate…not exceeding one hundred acres…to carry on the business of keeping hotels, restaurants, stores and places of amusement; to maintain a club-house, library, reading room and art gallery; to provide exhibitions and sports of all kinds for the amusement and recreation of its stockholders and the public generally.*

In order to help market the club and surrounding property to potential new residents, the Belle Haven Land Company printed up brochures that depicted quite a nice (and rather accurate) image of the local waterfront:

Of the many beautiful spots on the borders of Long Island Sound none is more beautiful than Greenwich, Connecticut. It possesses not only the charm of its natural advantages, which, without exaggeration, are innumerable, but is also of historic interest.

When it came time to build a clubhouse for the new project, the architectural firm of Boring, Tilton and Mellon was commissioned for the job. Completed in June 1892, the opening ceremony was held just a few weeks later, on July 4, highlighted by a simply extraordinary gala event that lasted into the evening.

Activities during the first years included boating (both sail and steam), swimming, tennis (two clay courts), horse shows and entertainment that boasted live music and theatrical performances. In addition, there were a variety of competitive games such as tub races, senior one-hundred-yard dashes, senior bicycle races, a half-mile junior bicycle race, a ladies-only bicycle parade, three-legged races and baseball throwing. For a brief period, there was even a nine-hole golf course situated on the piece of land just west of Harbor Drive. Shortly after, however, the "links" property was used for the construction of new homes.

There began a shift in the atmosphere of the Greenwich Casino Association during the 1920s that eventually led to a new name and a modified purpose. The Beach Club was officially formed on January 20, 1926, by founders John A. Topping, Sherburne Prescott, Frederick K. Caston, Lynde Selden and Robert P. Noble. Open only during the summer months, the revised mission was

to establish, maintain, control and operate a club for the encouragement, development and enjoyment of bathing, tennis, boating and other games and sports for the promotion of social intercourse among its members, to provide for their amusement and recreation and to generally do whatever may be deemed for the advancement, benefit, diversion and pleasure of its members.

As part of the club's new image, the old bathing pavilion was to be replaced, although many people were not pleased with the proposal. In the book *Centennial in Belle Haven: A Club for the Fun of It*, Edward Hamilton Malley fondly remembers the original structure: "There were steps leading down to the water. At high tide the water came right up to the pavilion float, and I could make a shallow dive right off the steps."

A lifeguard stood watch in a rowboat just off the shoreline.

The new bathhouse was placed forty feet back from the site of the original bathing pavilion, allowing for a larger beach area. With the updated design, the lifeguard was now able to keep an eye on things from a land-based perch.

The first club swimming pool used the salt water from Long Island Sound and was opened on July 4, 1929. It was sixty feet long.

The Beach Club, like its predecessor, remained open only seasonally. As a matter of fact, the latest in the season that the club ever remained in operation was October 28, and that was about 1956, when platform tennis became the first "winter" activity.

Boating at the club, although a part of the initial proposal in 1889, did not experience much growth until 1953, when member John (Jack) A. Dietze launched his new Mercury, the first of its kind along the local shoreline. The vessel was a fifteen-foot fiberglass sloop and could comfortably accommodate four passengers while cruising. It was also easily managed by a crew of two while racing.

The Mercury was soon recognized as a viable option for sailors, as reflected in the following insight offered by Jim Grant, club boating chairman at the time: "The Mercury appears to be an ideal craft for our membership...We have tested the boat in winds up to 30 knots and find it extremely stable, a factor which, combined with its simplicity, makes it ideal for sailing for the teen-age group."

Within a few short years, there were twenty-three more Mercuries at the club. The adults competed in them on the weekends, and the juniors practiced in them during the week. The introduction of the Mercury to the club scene has been recognized as one of the major contributors to the success of the junior program. Eventually, Lightnings and Blue Jays were added to the junior fleet.

The young skippers began competing in interclub events and were performing quite impressively. As a way for the up-and-coming "beach club" sailors to gain more respect from other, more formal "yacht club" competitors, they started to refer to themselves as the Belle Haven Junior Yacht Club.

With this new interest in yachting, nearly one hundred boats were moored in the Beach Club harbor by 1961.

It was about this time that the juniors started to push for yet another name change, suggesting the formal adoption of the Belle Haven Yacht Club.

The club almost did select that new label, in fact, but after careful consideration and an appeal from the non-boaters and those wishing to

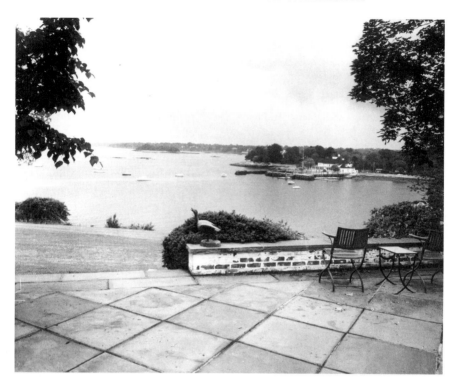

A view from the Belle Haven Club. *Photo by Town & Country Studio of Photography, Greenwich, Connecticut, from the collection of the Greenwich Library Oral History Project.*

maintain the tradition of the club up to that point, it was agreed that the title "Belle Haven Club" would be in the best interest of all. At a meeting on December 11, 1962, it became official.

The saltwater pool was in great disrepair during the 1960s, so it received a long-overdue facelift. The clubhouse itself has experienced a number of additions and remodeling projects over the years, reflecting a continually increasing membership and an ever-growing schedule of activities.

The Belle Haven Club is located in the exclusive community of Belle Haven on Harbor Drive. Boasting magnificent views of Long Island Sound, the club today offers the finest in yachting, tennis, dining, swimming and beach opportunities and retains a reputation of extreme prestige.

9
The Yachtsman
E.C. Benedict

Elias Cornelius Benedict was a successful Wall Street broker, banker, businessman and investor from New York City who purchased land in Greenwich during the early 1900s. He was most commonly known as Commodore E.C. Benedict, earning a reputation over the years as being one of the forerunners in yachting in the country.

Benedict was an avid and passionate yachtsman who knew how important it was to get out on the water whenever possible. According to his obituary published in the *New York Times* on November 24, 1920 (he passed away at the age of eighty-seven), Benedict had been previously quoted on his seventy-ninth birthday as sharing the following sentiments about balancing work and play:

> *For sixty-four years, I was in Wall Street, the centre of our financial storms in this country and the reflex of all the financial storms abroad, and how I was able to stand it I do not know, unless it was through the inherited strength I possess. And, speaking of Wall Street, I would like to say that I never invited anybody to go into it, and I have invited many to stay away from it.*

When asked if he had plans to retire during the same interview, Benedict replied:

> *It is better to bust out than to rust out. We old fellows eventually get to an age where we like to sit in the grandstand and watch the trotters go by. And*

The deck of the yacht *Oneida*, owned by E.C. Benedict. *Courtesy of the Greenwich Library Oral History Project.*

do the present generation go too fast, you ask me? Well, perhaps there are dangers in the rapid gait, but I think that the pace would be counteracted in most cases by outdoor sports if not followed to excess. As for me, I took up yachting, although I would hardly call that exercise, because I had reached such a state that my physician said that I would have to do something of that kind to save my life. So for many years I have kept a yacht and found that fresh air and sunshine are important factors in the prolonging of life.

Benedict traveled on his yachts extensively, visiting such exotic ports of call as the Bahamas, South America, the West Indies and the Amazon River.

His well-known yacht *Oneida* logged some 275,000 miles with Benedict at the helm.

The Benedict estate was located at the site of the old Americus Club, which had previously been owned by Bill Tweed, on Indian Harbor. The property had a windmill, so Benedict was able to maintain his own water supply. He grew a lot of his food in his own gardens. There were pigs, chickens, sheep and cows, so Benedict and his family were able to have their own milk and meat. He also had his own icehouse, and coal was delivered directly to his dock. The estate had its own painter's shop and carpenter's shop, along with a staff of professionals who were on call for all of Benedict's needs. There were huge greenhouses for fruits, vegetables and fig trees. Benedict had his own gashouse where he made acetylene gas. The estate had several gaslights throughout all the driveways, houses and stables. To put it simply, Benedict was very self-sufficient.

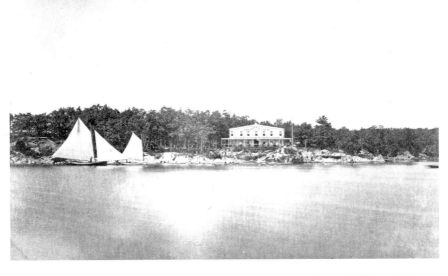

The Americus Club as seen from Tweed Island. *Courtesy of the Greenwich Library Oral History Project.*

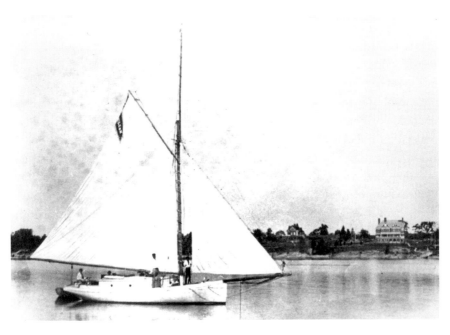

Sailing off the Greenwich shoreline. *Courtesy of the Greenwich Library Oral History Project.*

Benedict used the adjacent Tweed Island, which was about three acres in size, for hay. His horses would regularly swim out and graze on the hay.

The main house had an elevator in it for its multiple floors. A staff of twenty-five was employed full time to keep things in pristine condition. There were two beaches on the property—a front beach and a back beach. Each had its own bathhouse.

There was a head coachman who lived on the estate with his family, and there were apartments over the stables for the rest of the equine staff. A gardener and his family had a house on the property as well, and another employee lived with his family in the gatehouse. The farmer and his family also lived on the estate.

The stable tower had a magnificent clock in it, with four rather large faces. People who lived in the area at the time recalled that it was so large that it could be clearly seen all the way down Mead's Point. A loud bell struck every hour.

There was a boatyard on the property that had rails for pulling in the floats and small vessels. Benedict used the former Americus Club dining room as his new boathouse after moving it from the original site down to the water's edge. It was set up so that one end opened to allow boats to drift in and attach to a float within the structure. Pulleys and tracks lifted the boats up in order to keep the hulls clean. Benedict hired a full-time crew to work in his boatyard. He owned a large yacht that was pretty much used as his regular transportation, as well as a number of smaller boats, including a handful of launches. The *Oneida*, nearly two hundred feet long with a twenty-four-foot beam, a twelve-and-a-half-foot draft and weighing six hundred gross tons, had anywhere from thirty-five to seventy crew members working on board at the height of the season.

One of the most famous tales about the *Oneida* was the "secret" medical operation of President Grover Cleveland. As the story goes, President Cleveland underwent major surgery aboard the *Oneida* on July 1, 1893. Not wanting to worry American citizens, government representatives simply stated that the president had some teeth extracted. In reality, he had had a cancerous lesion removed from his jaw. As a matter of fact, he had a second operation just two weeks later to remove more tissue, also aboard the *Oneida*. The reason that the Greenwich yacht was chosen was because Benedict and President Cleveland had been longtime friends, and the president knew that his colleague could be trusted.

After Benedict's passing, the *Oneida* was sold to the International Film Service Corporation of New York.

Benedict clearly boasted a colorful, passionate and larger-than-life personality. His contributions to the international yachting community will forever hold a place in maritime history.

OYSTERING

During the late 1800s, nearly three-quarters of the entire oyster export to Europe came from Connecticut, with Norwalk being the major contributor. During that era, there was said to be, on average, an amazing 160,000 barrels of oysters shipped abroad annually.

One of the first oystermen in Greenwich was William Chard (son of Henry Chard, the original family member to settle in Greenwich during the mid-1600s), who moved to Cos Cob from Nyack, New York, before the Civil War. His nickname was "Boss," and he came from a family of shipbuilders.

Once here, Chard accepted a job at the Palmer and Duff Shipyard as a boat designer and builder. Following generations of Chards, he continued the boat building legacy, creating most of his masterpieces on Brush Island, off Mead's Point to the west. Captain Samuel Chard, a descendant of William, began oystering off the Greenwich coastline during the 1870s. By the turn of the century, shellfishing had become a popular and lucrative business for local fishermen. Clarence Chard joined his father (William) and uncle (Stanley) in the oyster business in 1918.

Clarence Chard was born on Indian Harbor Drive on October 12, 1899. Even as a young boy, he had a strong affection for the water and boating, heading down to the docks with his father whenever he had the chance. After graduating from high school, Clarence started working with his father and uncle. Loading the market boats that came from New York was his primary job. At that time, their oyster boat was the *Clara Palmer*, a vessel that had been converted from sail to power in order to make the trip

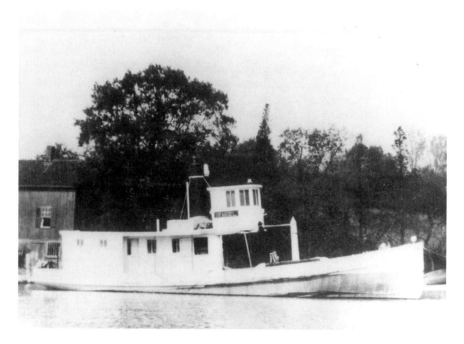

An early steam oyster boat owned by Charles E. Palmer at the turn of the century. *Courtesy of S. Pierson Palmer, from the collection of the Greenwich Library Oral History Project.*

more efficiently. Before that, only sailing oyster sloops (or scows) delivered the cargo. Oyster scows were sometimes called barges, as they boasted a cabin house on board where the oystermen could open (or shuck) the oysters as soon as they were hauled onto the boat. During the early years, there were about thirty oyster sloops operating out of Greenwich. At the turn of the century, that number dropped to about a dozen, primarily due to the fact that places farther north in Massachusetts and Rhode Island were able to provide a healthier and more plentiful stock of oysters. The local fleet included the *Ann Gertrude, Florence T., F.E. Webster, Fannie S., Piano, Emma Jane, Sarah Lucinda, Susie C., Samuel Chard, Priscilla, Ada, Dora Dean* and *Allie Ray*.

An entertaining story is that one of the last schooners that William Chard built was running a shipment of onions from Southport to New York when it was caught in a bad storm. Running up on the rocks near Hell's Gate, all of the onions fell off the ship. It has been noted that onions could be seen in the water all the way down to the Battery.

Chimney Corner was an area located on the east side of the old Benedict estate, which ran up to the Bruce Park area, where many boats were built. (It was named Chimney Corner because they used to make pottery there and had a chimney.) The *Samuel Chard*, launched in 1900, was one of the vessels constructed at that location.

The Chard, Ford and Palmer families owned the primary oystering businesses in the area during that time. The Chards' oyster grounds were mostly situated off Field Point, outside Captain Island and Greenwich Point. The Ford Oyster family ran from the east side of Old Greenwich, and the Palmer Oyster family operated from the west side of Old Greenwich.

The price for a bushel of oysters during the early 1900s was anywhere from four dollars to eighteen dollars. Seed oysters went as low as forty cents a bushel.

When oystering was not doing well, the fishermen went clamming to help make up for the loss. To try and deter oyster pirating, a watchman's station was constructed on Bluff Island (or Cat Nap Island and Bole's Island at one time) at the mouth of the Cos Cob Harbor.

In an oral history interview conducted by Richard W. Howell, Horace H. Bassett shared his memories about the oyster business back in the day:

The oystermen had their beds right out in Greenwich Harbor just off the yacht club and off Mead's Point. All the oyster stakes were set around. They had their beds marked out with stakes, just like you would a garden. They had certain areas where they planted the seeds, and they allowed them to grow there. Of course, the water was so pure in those days that it was perfectly safe. Besides taking care of and harvesting the oysters, they had to service them, you know. They'd have to keep sweeping them to get rid of the starfish, so you'd see these oyster boats out there just going around in circles and circles and circles, sweeping the starfish off the oysters.

They had a long chain that they would drop down, and on the end of the long chain there were iron weights of some kind, and then it looked like cloth waste. You know the waste that painters used to use, stringy material? Well, masses of that. The starfish, you know, have little rough edges on them. The surface is quite irregular, and that would sweep them up.

I can remember these stakes used to be broken off in the wintertime. The ice would break them off, and they'd be down under the water. And if you were swimming out there or diving off a boat, you had to be rather careful because you were liable to hit one. They had to put in new stakes all the time. They must have been thirty feet long, these stakes, because they went

down in the mud and you couldn't pull one up. We would row out and tie up to one with the boat and fish, and it would be like an anchor for us. It was just an ordinary wooden stake stuck in the ground, a portion of a tree.

The Chards used to use Brush Island; we always called it Chard Island. It was right across the water from Tweed Island. It was an island that nobody used, and the Chards used it. They used to pile up the old oyster shells on there, and then, when they seeded them, they'd take them on out and put them down for the seed to attach to.

On that island I also remember seeing they had the cabin of a boat that was wrecked on the end of Mead's Point, and it still had the name on it, the S.E. Spring. It was a ferryboat that was plying up and down the Sound, and a storm—I guess it was a southwest storm—drove it into Greenwich Harbor and right up into Mead's Point. Well, the cabin of that boat sat on Chard's Island, and they used that as a shed. It was there for years and years, and the name and the windows on it were just perfect. I suppose they went and took it off the wreck and floated it over there and brought it up on the island. The boiler from the old wreck is still there off Mead's Point. Two or three years ago I remember going by in a boat and seeing it there. Of course, it was there as we were children, and a lot of other ironwork was around by the boiler.

Now, the oystermen also went out for quahogs or hard-shell clams, but they would get those in a rowboat. They would have a long pole with a curved rake on the end; it had a T-top that they got ahold of, a handle in the form of a T. They'd just keep working that up and down in the mud, and after they did that for a while, they'd bring it up and lay it over the boat. The mud would wash off, and there'd be hard-shells or cherrystones in the rake. The rake was curved just like your curved hand, and the prongs were close together so that the mud would wash out.

Oh, that was really hard work, because they never anchored their boat. They had a hold of the ground, the mud bottom, with that long rake, working that in through the mud.

Chard's Island is where the oystermen kept their equipment and also their extra lobster shells that they would pile up to take out to plant the seeds on. But they also used that island to pull their boats up. They'd probably do that several times a year to clean the hulls and paint them. They'd do that, of course, between tides. I can remember they'd do one side and then roll the boat over, pry it on over, and do the other side. They also built one or two boats on the island, and of course that was a job. You'd see them working on those week after week, building a full boat on Chard's Island.

The oystermen were all business; that was their livelihood. But everybody's so friendly out on the water. It isn't like driving an automobile. In an automobile everybody's against you; in the water everybody's with you. We would row along up to the oyster boat, and they would give us four or five clams or oysters, and then we'd take them in on the beach and eat them. And even if we weren't getting anything from them, always waving hello. And if anybody was in trouble ever, you could always rely on help when you were out on the water.

The "planted" oyster business in Greenwich found its start in the mid-1800s. Before that, natural beds were the only source of oystering. Captain Henry S. Lockwood is credited with being the first to plant shells at the mouth of the Mianus River. Once that initial crop had matured, it was harvested and sent off to market. Immediately after, new shells were planted. With Lockwood leading the way, other oystermen soon followed. The other original oystermen in the group included Nelson Studwell, Abraham Brinkerhoff, Andrew Ferris and Samuel B. Lockwood.

The oyster "setting" season was from June to September. The protected waters of the harbor and inlets were preferred locations for the oysters to set, as opposed to the fast-flowing currents in more open water. However, places

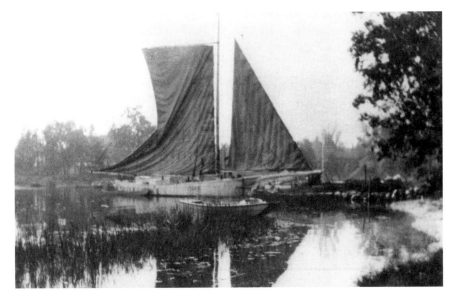

The oyster boat *Ann Gertrude*, owned by Benjamin Palmer in 1915. *Courtesy of S. Pierson Palmer, from the collection of the Greenwich Library Oral History Project.*

such as Bridgeport and Stratford had what they called "natural" beds; in other words, sea bottoms that were hard rather than muddy.

Although oystering still continues today in Connecticut, it will never again quite reach the level of success that was seen during its heyday as the greatest oyster resource in the world.

THE PALMER ENGINE COMPANY

The Palmer Engine Company was founded during the late 1880s and was originally located on the Old Post Road near the Dumpling Pond Bridge in North Mianus and Palmer Hill. The plant was near the river and was operated by water power. There were approximately forty to fifty employees working there during the early days, but by the 1930s, that number had nearly doubled.

Two brothers named Frank and Ray Palmer ran the company. Frank was savvy in business, and Ray was a highly skilled engineer. The two talents nicely complemented each other, bringing great success to the maritime venture.

Under Ray's engineering tutelage, the Palmer Engine Company produced an impressive and extensive line of marine engines for all types of vessels. Both Frank and Ray, although serious about their business, also had casual attitudes, which helped to create a family atmosphere among both employees and management. As a matter of fact, most of the employees spent their entire working careers at the Palmer Engine Company, some staying on well into their late seventies and even eighties before retiring.

The Palmers treated their staff very well, purchasing many houses near the company site that they offered to their employees at an extremely reasonable rent and always kept in good condition.

Interestingly, the old Palmer plant originally produced telephones. When it decided to make the transition to engines, it initially built the two-cycle model (an engine that is without mechanically driven valves, with fuel and air entering through ports in the cylinder. The two-cycles are composed of a piston being compressed and then released).

The first two-cycle engines were two horsepower, so they were rather small, weighing only about fifty or sixty pounds. Since spark plugs had

not yet been invented, a "make and break" system that propelled a set of points within the cylinder was used. The Palmer Engine Company developed an innovative and successful "make and break" system of its own around 1895, and to show what a great system it was, nearly fifty years later one of the engines was discovered in an old boat, still in working condition. That original Palmer Engine Company model was so well designed, in fact, that it earned the reputation as being "the Granddaddy of Them All."

The company eventually produced six different sizes of the two-cycle engines, which were shipped to ports all over the world. They included the YT, NR, RW, ZR, F and NK and were used for small rowboats, fishing boats and tenders. Their biggest clientele at that time were the fishermen.

As the business was growing, the original plant became too small to work from, so the Palmers decided to move the operation to a location at Palmer Point, near River Road in Cos Cob, during the early 1900s. At that locale, they were able to construct multiple buildings and offices and also had room to employ more workers.

Since there was no electricity in those days, everything operated by the power of steam. One large steam engine provided energy to the plant via a

Palmer Point. *Photo by Town & Country Studio of Photography, Greenwich, Connecticut, from the collection of the Greenwich Library Oral History Project.*

two-hundred-foot line shaft. There was only one light, which powered off the steam engine, so most workers had to use candlelight to see during the short days of winter.

The Palmers began making a four-cycle engine about 1910 that was powered by valves, which opened and closed mechanically. The four cycles included the intake stroke, the compression stroke, the firing stroke and the exhaust stroke. These engines weighed as much as three thousand pounds and could easily last fifteen to twenty years, even in saltwater and under the harshest of sea conditions. The Palmers offered one-, two-, three-, four- and eventually six-cylinder options in their four-cycle engine line.

Part of the Palmers' business included a foundry that produced bases, manifolds, cylinders and the like. (In later years, Herbie Oarr took over the foundry under the name of the Square Deal Foundry.)

When Ray Palmer retired about 1915, Julius Ulrich joined the company as an engineer. Ulrich was a talented engineer who soon introduced a faster-speed engine, taking the six hundred rpm models up to twelve hundred rpm. The Palmer Engine Company began producing eight or nine models of the "new and improved" engine, including the impressively large GW-6 (or Greenwich Six), which offered twelve hundred rpm and 150 horsepower. Larger commercial fishing boats and charter boats used these, and when Prohibition came about, bootleggers used them as well. As the story goes, the bootleggers would come into the shop to have their engines fine-tuned on a regular basis (they obviously did not want to get stuck at an inopportune time).

The Palmers eventually got involved with boat building, producing mostly eighteen- to twenty-six-foot open-cockpit launches.

When diesel engines came on to the scene about 1938, the Palmer Engine Company started working with the Russell Newberry English engine, as it was quite impressed with the savings between fuel consumption and distance per tank as compared to the gasoline engines.

When Frank Palmer passed away, his son-in-law, Carl Hatheway, took over the helm. Although more of a real estate man than a marine engine man, Hatheway did manage to keep the business running profitably.

During the war, the Palmer Engine Company built engines for government torpedo-retriever vessels. Its first commissioned contract was for two hundred of those engines. The Palmer Engine Company, along with Universal, built all the engines for the old Liberty Ship Lifeboats during World War II (more than two thousand of them).

At the end of the war, Hatheway was tiring of running the company and decided to put it up for sale. It was sold to the Columbia Aircraft Products Company about 1946, but the new owners went bankrupt less than two years later. At a bankruptcy auction in 1952, Raynal C. Bolling Jr., Frank Hekma and Carl Hatheway made the high bid of $175,000 and took over the failing company. Hoping to get the business back on its feet, they brought back twenty-five of the old-timers.

Finally, in 1958, they started to see some improvement. Part of that was due to a new relationship they had created with the International Harvester Company building conversion engines, basically combining their rugged marine parts with the equally rugged International Harvester truck engines. The new line offered 20-, 60-, 120-, 150- and 200-horsepower models. Eventually, they also produced a 300-plus-horsepower converted diesel engine that the large commercial fishing boats absolutely loved. In addition, they developed other working relationships with reputable companies such as the Egg Harbor Boat Company in New Jersey and Luhrs Sea Skiffs in Marblehead, Massachusetts.

At that time, however, more and more competition was entering the engine production field. The Packard Motor Car Company, Chrysler and Mercury were just a few of the big names that began offering competitive marine engine models. To try to keep up, the Greenwich-based company brought in a fourth investor, John Gerli.

With the business still struggling, Frank Hekma eventually bought out the other partners in 1968. About a year after that, Hekma decided to close the doors. The old Palmer plant was demolished in 1974 to make room for the new Palmer Point condominium project.

Notable Residents of the Greenwich Waterfront Community

There have been many intriguing characters who have helped shape the history of the Greenwich shoreline over the years. With too many to include in this particular book, following are a few tales that will at least give you an idea of the eclectic collection of coastal residents who have played in our local surf.

Helen Meany Gravis was born on December 15, 1904, to Josephine Sullivan and William S. Meany Sr. She was the oldest of eleven children. Helen was a talented swimmer and diver, ultimately competing in the 1928 Olympics in Amsterdam. Her father worked for Commodore E.C. Benedict, at one point as manager of Benedict's Greenwich estate. Her father was also a proficient swimmer and always encouraged his children to become strong swimmers themselves.

When the Meany family decided to move from New York City to Greenwich, they first chose a location on Steamboat Road. Their new house had a little beach where Helen initially learned how to swim.

Eventually, Gravis swam at the Indian Harbor Yacht Club when it had a beach. At the time, the only swim competition in the area was at the Indian Harbor Yacht Club held every Labor Day. Gravis did quite well at that event, and her father saw potential for her to get even better. With that in mind, he decided to bring his daughter to an AAU (Amateur Athletic Union) meet in Rye, New York, held at Oakland Beach. There she won her first race at the age of thirteen. At that point, the manager of the Women's Swimming Association of New York asked her father if he would allow her to join the club. He agreed, and Gravis began competing at swimming and diving meets all around the area. Since there was not much opportunity

in Greenwich back then to dive from a three-meter board or a ten-meter platform, the Women's Swimming Association of New York offered Gravis the chance to learn about high diving at its facility. Eventually, this would become her area of expertise.

Back in Greenwich, Gravis often practiced her swimming at Commodore Benedict's beach. Her father used to challenge her to dive from different locations, for example a float at the Indian Harbor Yacht Club that had a ten-foot board attached. Helen very much followed in her father's footsteps as far as her approach to new things. In an oral history interview conducted by Marian Phillips and Esther Smith, Gravis recalled: "He was a very strong swimmer and he was not a competitive diver, but he would try anything and I would try anything after him."

Gravis remembered that it was somewhat difficult diving at the Indian Harbor Yacht Club, as boats were constantly going in and out of the harbor, throwing wakes and tossing the float and diving board all over the place. Good dive platforms require a steady base, especially ten-footers. It was hard to improve her skills due to the less-than-ideal diving conditions and her father's lack of expertise in the sport.

Eventually, the Indian Harbor Yacht Club beach was shut down, apparently due to its "unsafe" swimming locale. After the beach closed, the local swimmers moved over to Island Beach. Gravis and her friends went almost every day, and one of their favorite activities was "stunt-the-leader on the low board." The way it worked was that each person would attempt her version of frontward and backward somersaults, and then the next in line would try to out-do the previous diver's performance. It has been noted that, although the energy and enthusiasm were worthy of the gold medal, the technique, skill and form left much to be desired.

During one of the meets in Rye, Gravis watched diver Alice Lord Landon perform from the ten-meter platform (or tower), and she knew then and there that she wanted to be a platform diver herself. As she pursued this new ambition, she went through a humbling number of trial-and-error lessons. Whereas most divers start low and then go high, Gravis went the opposite way. At the beginning, there were many belly flops, but she would go back, try to figure out what she did wrong and attempt it again. Gravis would observe other divers who had more success and then try to mimic what they did. Needless to say, it was somewhat intimidating to go from the eighteen-foot platform at Island Beach where she had trained on to the true ten-meter, which is thirty-three feet high.

Since her father was the chairman of the sports committee at Indian Harbor Yacht Club, he was in charge of organizing all of the swim and dive meets. At thirteen years old, Gravis was winning competitions against sixteen- and seventeen-year-olds. Eventually, she just kept winning them all, and the other swimmers pretty much gave up because they knew that either she or one of her siblings would always win.

As a result, both Gravis and her father agreed that it would be best for her to stop competing in club events. From that point on, she spent most of her time working on diving. Gravis would perform diving exhibitions at the club—to the enjoyment of all the members, since up to that point nobody had really seen high-quality diving before.

To practice her tower diving during the summer, Gravis would go to Manhattan Beach in Brooklyn, as it had a three-meter springboard and a ten-meter platform. It was pretty much an all-day affair, with four or five hours of travel, plus practice time. For a couple of years, there was a platform at Oakland Beach in Rye, New York. Gravis was about thirteen or fourteen years old at the time. The Women's Swimming Association used to rent time at the Colony Club pool in Manhattan one evening a week so that its athletes could practice. Unfortunately, the diving board was only about a foot from the water, but it was better than nothing. Back then, the Greenwich YMCA pool did not allow women. One time, however, Gravis remembers that they did host a swim meet between Greenwich High School and Ely Court.

When practicing from thirty-foot platforms, a diver's descent can often reach speeds of up to eighty miles per hour. If she were to hit the water wrong, it would really hurt. Because of that, fitness training was very important. Since Gravis did not have a professional coach at the time, there were many lessons learned the hard way.

After graduating high school at sixteen years old, Gravis attended Putnam Hall in Poughkeepsie for one year and then went on to Wellesley College. She stayed there for just one year before deciding that she wanted to try and compete in the 1924 Olympics. Ideally, she would have liked to have done both, but that was not a feasible option at the time.

Since Wellesley College was without a pool, the school offered Gravis the opportunity to follow a five-year physical education curriculum while teaching swimming and diving, but she turned it down. Boston also asked her to present diving exhibitions for the Red Cross, but Gravis did not feel that there was enough support there.

More and more people started hearing about Gravis's exceptional diving ability through the media, such as the *New York Times*. As she traveled the area performing exhibitions, other papers started following her achievements as well.

Her first truly memorable swim and dive meet was in Detroit, Michigan. At that event, Gertrude "Trudy" Ederle (of English Channel fame) and Helen Wainwright and Aileen Riggin (both accomplished and recognized swimmers) were there. Gravis recalled that it was very exciting to be a member of the team that broke the four-hundred-yard relay record, resulting in her and her teammates experiencing a great amount of publicity.

Gravis's overall Olympic career included competing at the 1920 Olympics held in Antwerp, Belgium, where she was eliminated in the first round of the ten-meter platform competition; the 1924 Olympics held in Paris, France, where she finished fifth in the ten-meter platform competition; and the 1928 Olympics held in Amsterdam, Holland, where she won the gold medal in the three-meter springboard competition. Gravis was the first woman to make three Olympic teams.

During the 1928 Olympics, Gravis and her teammates stayed aboard the SS *Roosevelt*. General MacArthur was in charge, and Gravis recalls that he was rather strict. Everyone was expected to be in his or her stateroom by 8:00 p.m. However, MacArthur eventually relaxed that rule and allowed them to hang out in the lounge further into the evening. Prior to competition days, the divers would stay in a nearby hotel, since they needed to be up by 5:30 a.m. for breakfast before practice.

Gravis's non-Olympic career included such highlights as winning the National High Diving Championship from 1921 to 1928, bringing home the gold medal in eighteen national championships as a teenager and being the only woman invited to perform in a three-day exhibition at Prince Chichibu's wedding to Matsudaira Setsuko in Japan in September 1928. She was also featured in underwater pictures taken by the well-known sportswriter Grantland Rice in Bermuda.

Gravis was inducted into the International Swimming Hall of Fame in Fort Lauderdale in 1971 as a United States diver.

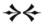

Victor Borge was an internationally famous musician and humorist who captured the hearts of thousands of fans throughout his successful career.

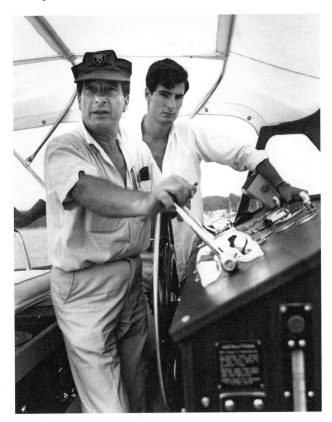

Victor Borge and his son, Ron, aboard his 1960s fifty-foot Chris-craft *Constellation*. *Courtesy of Ron and Nancy Borge.*

Born in Copenhagen, Denmark, under the name of Borge Rosenbaum, "Victor Borge" came to the United States in 1940. Unarguably a natural talent, Borge was featured on Rudy Vallees's radio show just a year later, in 1941. Within a short amount of time, Bing Crosby offered him a part in *Kraft Music Hall*. Borge received the Best New Radio Performer of the Year award in 1942 and was offered a part in a movie with Frank Sinatra. The *Victor Borge Show* made its debut in 1946, only six years after he arrived in the United States.

What many people are not aware of is that Borge had a fond appreciation and great passion for the water. His son, Ron, recalls:

> *There was nothing more special to Borge than for him to wake each morning and watch the sun rise over Long Island Sound from his Greenwich waterfront home. Borge always loved to say, "With me the three B's are Bach, Beethoven and boats."*

Victor Borge's 1972 Sparkman & Stephens ketch cruising on Long Island Sound. *Courtesy of Ron and Nancy Borge.*

Some of the impressive yachts that Borge owned during his lifetime included a fifty-foot Chris-craft *Constellation*, a forty-two-foot Egg Harbor Sportfish, a forty-six-foot Bertram, a seventy-two-foot Sparkman & Stephens ketch, a twenty-six-foot Diva Royal, a sixty-two-foot Custom motor yacht,

a fifty-three-foot Magnum Express Cruiser, a forty-foot Viking Express Cruiser, a fifty-six-foot Birchwood motor yacht, a forty-five-foot Magnum Express Cruiser and a fifty-six-foot Magnum Express Cruiser.

Borge was a member of the Indian Harbor Yacht Club, the Royal Danish Yacht Club, the New York Yacht Club and the St. Croix Yacht Club. The first trophy for the Stamford-Denmark Friendship Race hosted by the Stamford Yacht Club was awarded on one of his boats. Borge was a lifetime supporter of the race and has a perpetual trophy that is awarded each year at the event.

Even at ninety years old, Borge continued to enjoy skippering his twenty-six-foot Diva Royal speedboat and his fifty-six-foot Magnum Express

Victor Borge's 1926 Diva Royal. *Courtesy of Ron and Nancy Borge.*

Cruiser, both of which were docked in front of his Field Point Park home. His enthusiasm for the sea is evident in the fact that "The Little Mermaid" continues to watch over his grave site in the Putnam Cemetery in Greenwich.

Borge originally moved to Greenwich and purchased a four-acre piece of property overlooking Long Island Sound, where he lived until passing away at the age of ninety-one.

13

OTHER WATERSIDE
CLUBS OF GREENWICH

The Old Greenwich Yacht Club is located at Tod's Point and was established in 1943. It was designed for residents of the town to enjoy the sport of boating in an educational and social atmosphere. Walter Pendleton was the first Commodore.

The original clubhouse was built as a boathouse for the deep-water dock that, at the time, extended out toward Sand Island. When the town of Greenwich acquired the former Tod estate in 1945, the building that was to be converted to a clubhouse was actually known as the "three-car garage." It boasted double doors that opened to a work pit for servicing automobiles. A coal-fired boiler was the only source of hot water heat during the early years. Later, a porch and shed were added to the structure.

With the original dock lost to the devastating hurricane of 1938, a new one was built in 1949. Prior to that, boats would be pulled up on shore and then tied to pipes that had been placed in the sand. Larger vessels opted to anchor off the shoreline in the relatively protected cove area.

During the winter, club rowboats were stored and worked on inside the clubhouse.

There is a historical plaque on the club grounds that reads:

On July 18, 1640 Daniel Patrick and Robert Feaks landed on these shores in the name of the New Haven Colony to start a new settlement, later called Greenwich. This neck of land is called Elizabeth's Neck after Mrs. Feaks.

The pier at Greenwich Point and the Old Greenwich Yacht Club. *Courtesy of* Greenwich Time, *from the collection of the Greenwich Library Oral History Project.*

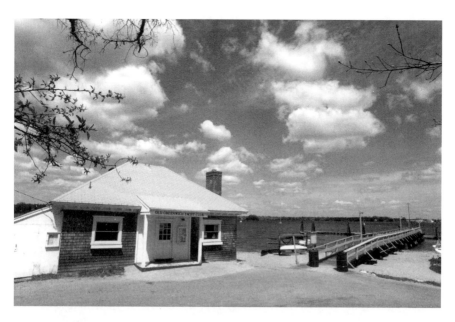

The Old Greenwich Boat Club. *Courtesy of the Greenwich Library Oral History Project.*

Tod's Point, Great Captain Island and the Greenwich Shoreline

The anchor above this tablet was given to the Club by Clyde B. Ford, a founder. It was taken from the Thames-sugarboat which sank by the point in April 1930.

Dedicated July 4, 1976

The Greenwich Boat and Yacht Club is located on Grass Island and was founded in 1938 by a group of businessmen that included Charlie Nelson, Charlie Knott and Otto Helbig. It was created as a way to encourage the sports of yachting and boating and other water-related activities and to make available the means for its members to pursue these passions. Working closely with the town, the Greenwich Boat and Yacht Club has developed ideas that have proved to enhance and promote boating and the local harbor. Today, there are approximately 285 members. The current clubhouse was built in 1955 and had sixty-five boat slips. Originally, the town sunk barges off the south end of the point. Eventually, a pontoon dock that runs north to south was constructed for small rowboats.

The Lee Haven Beach Club was located just off the Byram shore on a small island. Founded about 1949–50, it was considered to be "one of the milestones in the evolution of the recreational aspirations of the black people of this area."

At one point, the island (known as Shore Island) was used by rumrunners. During that time, the club was called the "Pieces of Eight Club." The island was bought in 1946 by Mr. J.O.P. Hagans from Mamaroneck, New York.

The Lee Haven Beach Club was primarily founded for professional black people from Connecticut; New York; Pennsylvania; Washington, D.C.; North Carolina; and other East Coast states. Early on, the membership came up against many challenges, including right-of-way issues, both on land and by water, and liquor permits. However, in one way or another, it somehow successfully navigated the obstacles.

When the club first opened on the island, there were already four buildings standing that provided fifty to sixty rooms that were used for a variety of purposes. The original clubhouse (from the Pieces of Eight Club) was in good shape, with a restaurant, bar, locker room and dock.

The island was less than an acre in size and boasted a fabulous beach overlooking Long Island Sound and the Greenwich shoreline. Electricity, telephone lines and gas were all supplied to the island from the mainland.

The club leased the island from Hagans and only operated during the summer months. A former captain looked over the island during the winter. Apparently, the captain had lived there since the Pieces of Eight Club days; he knew much of the island's history and was quite knowledgeable about the surrounding waters.

The club only lasted about four or five years, finally closing its doors, mostly due to financial difficulties. A major hurricane wiped out all the facilities and, ultimately, sealed its fate.

14

PACKET BOATS
AND STEAMSHIPS

As early as the 1600s, packet boats (or stage boats) were a popular means of transportation for people who wanted to get to distant places in a fairly short amount of time. Typically narrow vessels by design, they were created for speed rather than for aesthetics and were able to carry about sixty passengers.

The first mention of a packet boat in the Greenwich area was recorded in 1696 and ran from New York to Mianus, with passengers embarking from a landing located just beyond the bridge. Service began operating to Cos Cob in 1710 and then from Rocky Neck in 1725.

At the height of the packet boat era, there were any number of vessels running from those three locations at any given time. A partial list of those that ran to and from Mianus included the *Emeline, Caroline Peck, Adaline, Little Phebe, Edge Elnora, William S. Horner, Milton, George and Edgar* and *James K. Polk.*

Packet boats that frequented the Cos Cob dock included the *Plough Boy, Tradesman, Ann Maria, Billy Martin, Sarah Bush, Telegraph, Confidence, Fashion, Stella, J.C.R. Brown, President, Deep River* and *E.M.J. Beatty.*

Rounding out the fleet in Rocky Neck were the *George Washington, Theodore, Ann Amelia, Mary Willis, Comet* and *Locomotive.*

In addition to carrying passengers, the packet boats also used to bring cargo back and forth from New York. For instance, during the height of the potato season, nearly twenty-eight thousand bushels of spuds would make their way each week to the city. During the Thanksgiving and Christmas holidays, four thousand pounds of poultry a week could be seen leaving the

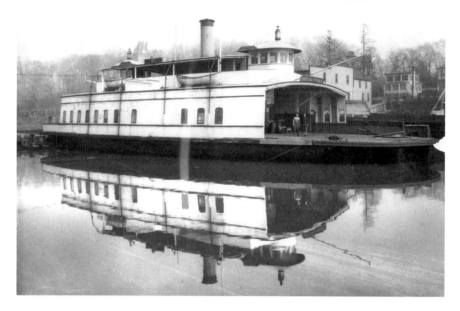

One of the ferry barges that regularly ran from Greenwich. *Courtesy of the Greenwich Library.*

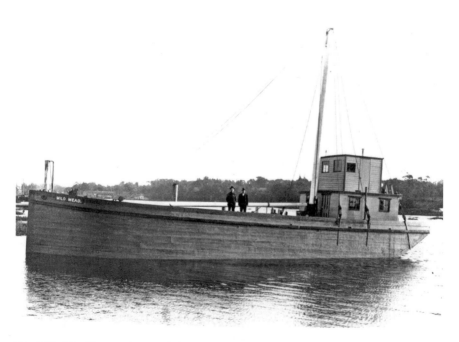

The Milo Mead barge. *Courtesy of the Greenwich Library.*

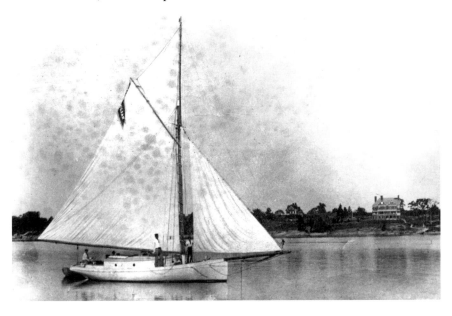

Sailing off the Greenwich shoreline. *Courtesy of the Greenwich Library.*

Greenwich dock, along with some fifteen hundred barrels of butter and 210 tons of hay. During the summer months, it was not surprising to see over six thousand barrels of apples shipped out.

Once the local crops had pretty much been depleted, packet boats were not needed quite as frequently. By the mid-1890s, packet boats carrying cargo had become a thing of the past.

Steamboats came onto the local scene during the early 1800s. A few of the more notable steamships that regularly visited Greenwich were the *John Marshall, Stamford, Norwalk, Fairfield, Nimrod, Cataline, Cricket* and *Oliver Wolcott.*

William M. Tweed was a founder of the Greenwich and Rye Steamboat Company, which began operation in March 1866. Captain Thomas Mayo was the president, and Sanford Mead was secretary.

The Greenwich and Rye Steamboat Company primarily ran the *John Romer* to and from New York. Its reputation was for being the "fastest one on the sound."

The *John Romer* could accommodate up to three hundred passengers and was often filled to capacity. The steamboat ran for two years before it was sold. The *Shady Side, Shippan, Nellie White, Greenwich, Maid of Kent* and *General Putnam* were a few of the steamboats that succeeded the *John Romer.*

THE DEVASTATING HURRICANE
OF 1938

On September 21, 1938, the worst storm in the history of Connecticut barreled through Connecticut without much of a warning. Referred to as the "Long Island Express," the devastating hurricane caused extensive damage all along the Connecticut shoreline.

As the hurricane made landfall, it was registering wind speeds of up to 160 miles per hour and dropping pellets of rain that were striking the ground like torpedoes. Even though Long Island typically acts as a protective buffer from the direct effects of the Atlantic Ocean for the Connecticut coast, the water surges coming from the sound were reaching heights never before seen in the state's history.

The storm started as intense rain during the midmorning on that unforgettable day and then steadily picked up in the afternoon, accompanied by extremely high winds. The high tide was due about 5:00 p.m., which caused a great amount of concern among the coastal residents.

To give you an idea of just how intense this storm system was, at the Riverside Yacht Club, trees were falling all around the club grounds as a result of the high winds and torrential rain. A boat ran aground on Great Island. Just as the eye passed over the area, the wind and rain came in even worse than before. The tide started coming in fast and furious. Cars were literally floating out of their garages. A number of people were caught in the rushing water and had to grab on to poles, trees and whatever they could get their hands on in order to survive. Tables, chairs and other furniture were afloat in the first floors of many shore-side homes. Residents who

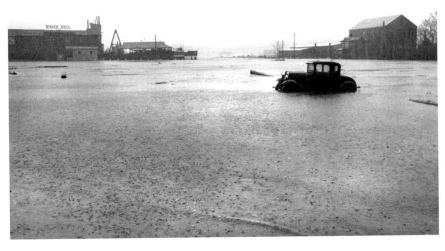

An automobile caught in the floodwaters during the 1938 hurricane. *Courtesy of the Greenwich Library.*

lived in Riverside during the hurricane can still remember wading in their own houses in water that was waist high—sometimes even as deep as four to six feet!

People in the neighborhood started pulling out their rowboats and going around to see who needed help. Members of the Riverside Yacht Club who were able to get to their yachts stayed aboard and kept an eye on the mooring field. During the course of the storm, they had to cut several vessels loose that had become hung up on their moorings. Other boats would tip completely over on their sides. The water totally covered the cars that were still parked in the club lot.

One Riverside family had water so high in their house that they had to go out the windows on the second floor in order to get to their canoes.

A grand piano was washed out to sea. One woman ordered her chauffer to drive her in her new Cadillac to get away from it all. Neighbors remember that all they could see was the roof of the automobile. Obviously, the chauffer and the woman had to leave the car and swim to a high and dry spot.

After that storm, many homeowners moved their boilers, washers, dryers and furnaces to the second floor to avoid losing them in another flood. Families also started performing pre-flood drills where everyone would practice putting furniture up on sawhorses.

To date, the Great Hurricane of 1938 remains the worst natural disaster to ever hit the Nutmeg State.

More Interesting Historical Facts about Greenwich

In no particular order, the following are a few additional intriguing facts about the history of the Greenwich waterfront:

1) A ferry used to run from Greenwich to Oyster Bay and Bayville on Long Island, bringing passengers and automobiles in the late 1920s and early 1930s.

2) Roger Baldwin Park is the former site of the Maher Brothers Corporation lumberyard. The Maher brothers were in the business of coal and building supplies, and sailing schooners from Newfoundland and Nova Scotia regularly delivered lumber to the company.

3) Port Chester resident Bill Wertley worked for Gans Coal during wartime. He owned a fuel barge, which was anchored off the Indian Harbor Yacht Club. Wertley used to sell gasoline and oil to service boats. Eventually, he purchased a powerboat named the *Robert P.* that was equipped with tanks. Wertley was an expert on all the small creeks, niches, inlets and outlets in the area and was a big help during the war, as he knew every little spot along the local shoreline to look for intruders. Sadly, the *Robert P.* sank during a huge storm while on its mooring.

4) The sugar boat *Thames* burned and sunk on April 24, 1935, just off the Greenwich shoreline.

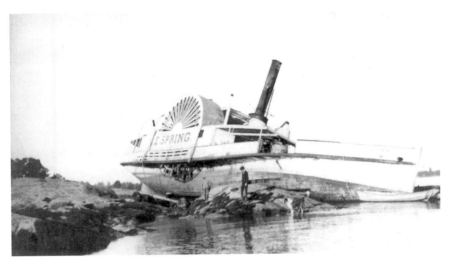

The *E. Spring* wreck off Mead's Point in 1903. *Courtesy of the Greenwich Library Oral History Project.*

5) The yacht *Lita* burned all the way to the waterline. Joe Peterson was the captain at the time. The boat drifted onto Chapman's Beach on Round Island.

6) Charlie Jensen, the owner of the old Jensen's Restaurant located at the foot of Greenwich Avenue, was entertaining guests aboard his boat when he inadvertently ran aground off Hens and Chickens.

7) Wee Captain Island once had a pilothouse from an old tugboat placed on the highest spot on the property. Bunks were built in it for guests.

8) The original police boat in Greenwich was donated by Sherburne Prescott. Prescott used to cruise on the boat in Florida but decided to give it to the town. Captain Bob Fitzpatrick was the first official marine policeman for Greenwich.

9) The thirty-eight-foot vessel *Blackhawk*, owned by Ray Bolling, was gifted to the town. Two new Palmer engines were installed, and it was used as a patrol/rescue vessel. During a major storm about 1949, the *Blackhawk* rescued some twenty-five people from a variety of perilous situations.

10) During World War II, the town of Greenwich utilized a seaplane that was kept at a small boatyard owned by Johnny Maher. There were

actually three seaplanes stored there—one owned by J.J. White, one owned by Johnny Maher and one owned by Sam Pryor. They were stored on pontoons and had to be washed down every time they went out and came back in. They were referred to as "ships" and were always set in an outward-facing position so they would be ready to go at any minute. Since there was no marine railroad to speak of at the time, a winch truck was used to place them on the dollies. Eventually, the Harbor House was built at that location after the Maher brothers decided to sell the land. Later, it became the Showboat. Originally, it was supposed to be a remote control factory, but that never came to fruition.

11) The Chard family owned two oyster boats, the *Hope* (which was eventually donated to the Norwalk Museum) and the *Samuel*.

12) Clarence Palmer from Riverside owned the oyster boat *Clara*, which was eventually purposely sunk just south of Greenwich Point.

13) Several boats were built on Brush Island, including the oyster boat *Hope* and *Skipper* (a 1928 work boat constructed for the town to tow floats and pontoons and to set out moorings for navigational markers).

14) Steamboat Road has been the home to coal yards, lumberyards, sand and gravel yards, oil yards, hotels, restaurants, corporations and private homes throughout its long and colorful history.

15) Bow-to-stern mushroom anchors and moorings were set in the "lagoon" area (former mud flats) around Baldwin Park in order to accommodate more vessels.

16) The *Hal Rose* was a black-hulled sloop out of Greenwich Point owned by Harold Palmer, Clarence Palmer's nephew. The boat was named after Harold and his wife, Rose.

17) The site of the former Chart House Restaurant in Greenwich used to be the home of a cider mill.

18) At one point in time, the Mianus River was the line of demarcation between the English and Dutch colonies.

19) The first trolley through Greenwich crossed the Mill Street Bridge on August 17, 1901. The trolley was run by the New York and Stamford Railway Company, and the cost for a ride was five cents. The trolley service lasted until 1927, when it was replaced by the bus and automobile.

20) At the turn of the century, the Byram River was much wider than it is today.

21) An old volcanic outcrop approximately thirty feet long, ten feet wide and eight feet high was once used as the local "diving rock."

22) The *Florindia* was a seventy-two-foot motor yacht that Mr. Binney had built in his front yard. He often took friends, family and neighborhood children on all-day excursions on Long Island Sound. "Captain Stanley" would bring his younger guests to "Molasses Gut" on Lloyd's Neck, where sand had been mined, creating a great swimming hole.

23) The Greenwich Yacht Club was organized in 1885 but was in existence for only three years. It was never incorporated, and the clubhouse was part of the loft of the steamboat dock house. The first floor of the building was occupied by a storeroom for freight and was also the site of the Rockport Hotel.

24) In 1897, the Town of Greenwich commissioned a dredging company from Hartford to dredge Greenwich Harbor so that deeper-draft vessels would be able to reach farther up the shoreline. Before that, cargo-carrying ships and barges had to anchor off Round Island and then transport their cargo to the mainland on rafts.

25) A brochure for the Shorelands Cottage Colony on Greenwich Cove in 1909 advertised its romantic atmosphere and picturesque water views. It also claimed to be "free from malaria and mosquitoes."

26) The first steam vessel utilized for oystering in the area was constructed in Cos Cob by Captain Henry S. Lockwood in 1878.

27) Muriel Wheeler Marsh, a member of the Indian Harbor Yacht Club, sailed since she was a child and competed in many events over the years. She

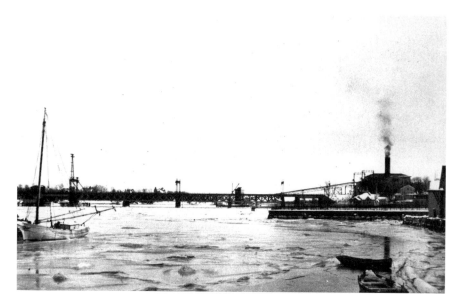

The Cos Cob Railroad. *Courtesy of the Benton Museum at the University of Connecticut, from the collection of the Greenwich Library Oral History Project.*

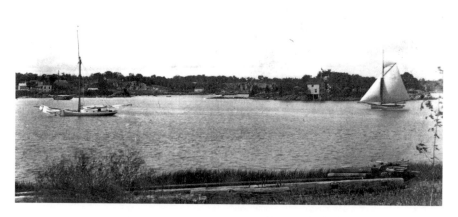

Yachts cruising off the Greenwich shoreline. *Courtesy of the Greenwich Library.*

was such a passionate boater, in fact, that she was featured in an article published in *Boating* magazine in June 1964. The interview occurred just before she left on her eighth Bermuda Race. To show how avid a boater Marsh was, she once competed in the highly anticipated contest with her leg in a cast—and she was seventy years old at the time! Her onboard responsibilities included preparing three healthy and tasty meals a day for fourteen crew members. That year, Marsh was sailing on the highly acclaimed *Cotton Blossom*, a seventy-one-foot yawl that was owned and captained by her brother, Walter "Tiny" Wheeler, and navigated by her husband, Carlton Marsh.

28) The former Ole Amundsen's Boat Yard was located on the creek that divides Riverside and Old Greenwich. It was a very successful boatyard in its heyday, even with the mud flats that surrounded the property at low tide. Amundsen's son, Erik, eventually took over the business, continuing the legacy of outstanding boat repair for which the Amundsens' were well known. Sadly, they are no longer in operation.

The Waterfront Today

W hat started out as a unique and extraordinary shoreline long before the first settlers arrived has grown and evolved over the years into one of the most charming and exceptional coastal towns in all of New England, if not the entire eastern seaboard. Still flourishing, still thriving and still a preferred destination for the elite yachtsman and coastal aficionado, the Greenwich waterfront continues to uphold an image of great prestige and respect. With the subcommunities still established as independent areas, Greenwich, as a whole, maintains its reputation as being an exclusive and undivided town.

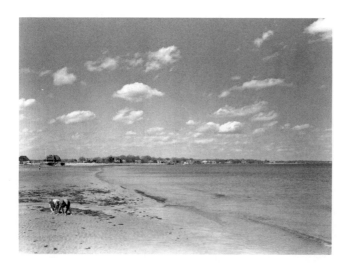

Greenwich Point.
Courtesy of the
Greenwich Library.

Tod's Point, Great Captain Island and the Greenwich Shoreline

Throughout its development, Greenwich has successfully withstood the tests of time. Wars, extreme financial challenges and the wrath of Mother Nature are just samples of the struggles the town has endured. By working together and creating a strong and stable foundation from the beginning, the residents who have lived here throughout the centuries have proved to be survivors.

Today, magnificent homes, great shopping, fine dining and a variety of other wonderful opportunities abound along the Greenwich shorefront. With all the advancements and conveniences of modern times, however, it is fascinating to learn that people are drawn to this pristine location for mostly the same reasons as their ancestors were centuries ago, the main reason being that when it comes to where the land meets the sea, Greenwich is, by far, one of the most beautiful and endearing spots on the East Coast.

BIBLIOGRAPHY

Anable, Anthony, and Cameron S. Moseley. *The Riverside Yacht Club Centennial Log: 1888–1988*. Riverside Yacht Club, 1989.

Bott, Penny. *Mead's Point Boyhood: An Oral History Interview with Whitman Mead Reynolds*. Greenwich, CT: Greenwich Library, 1977.

———. *Steamboat Road and Nora Stanton Barney: An Oral History Interview with John Barney and Rhoda Barney Jenkins*. Greenwich, CT: Greenwich Library, 1978.

Bott-Haughwout, Penny. *Shell Island: Two Views of a Magic Place: An Oral History Interview with Alberta Kristoff and Mary Leinbach*. Greenwich, CT: Greenwich Library, 1997.

Carley, Rachel. *Building Greenwich: Architecture and Design, 1640 to the Present*. Greenwich, CT: Rachel Carley and the Historical Society of the Town of Greenwich, 2005.

Clarke, Elizabeth W. *Before and After 1776: A Comprehensive Chronology of the Town of Greenwich: 1640–1976*. Greenwich, CT: Historical Society of the Town of Greenwich, Inc., 1976.

Curtis, Marge. *Island Beach: An Oral History Interview with William Erdmann*. Greenwich, CT: Greenwich Library, 1979.

D'Entremont, Jeremy. *The Lighthouses of Connecticut*. Beverly, MA: Commonwealth Editions, 2005.

Driscoll, Christie. *The Rippowam Mill and the Belmont Feed Company: An Oral History Interview with Anthony R. Belmont*. Greenwich, CT: Greenwich Library, 1977.

Howell, Richard W. *Bruce Park and the Benedict Estate: An Oral History Interview with Horace H. Bassett, D.D.S.* Greenwich, CT: Greenwich Library, 1978.

————. *The Lee Haven Beach Club: An Oral History Interview with Alver W. Napper, Sr.* Greenwich, CT: Greenwich Library, 1976.

Hubbard, Frederick A. *Other Days In Greenwich.* New York: J.F. Tapley Company, 1913.

Jewell, Karen. *A History of the Rowayton Waterfront.* Charleston, SC: History Press, 2010.

————. "Long Island Sound Is Still Just A Baby." *Norwalk Hour,* July 25, 2002.

Keogh, James, ed. *Centennial in Belle Haven: A Club for the Fun Of It.* Greenwich, CT: Belle Haven Club, 1989.

Kirkpatrick, Konstance. *The History of the Indian Harbor Yacht Club: 1889– 1977.* Indian Harbor Yacht Club, 1978.

Kowalski, Suzanne. *Oystering: An Oral History Interview with Clarence Chard.* Greenwich, CT: Greenwich Library, 1976.

————. *Sound Beach, Riverside, and the Greenwich Trust Company: An Oral History Interview with F. Reginald Gisborne Jr.* Greenwich, CT: Greenwich Library, 1977.

Lauricella, Billie. *Covering the Waterfront: An Oral History Interview with Charles J. Borchetta.* Greenwich, CT: Greenwich Library, 1995.

Mead, Spencer P. *Ye Historie of Ye Town of Greenwich.* New York: Knickerbocker Press, 1911. Reprint, Harrison, NY: Harbor Hill Books, 1979.

Moffly, Donna, ed. *Greenwich Review: Greenwich Celebrates 350 Years.* N.p., 1990.

Ornstein, Barbara. *The 1938 Hurricane in Willowmere: An Oral History Interview with Paul P. Palmer.* Greenwich, CT: Greenwich Library, 1976.

Ornstein, Barbara, and Margaret J. French. *Riverside from the Twenties Through the Fifties: An Oral History Interview with Ellen Harcourt, Charles and Katherine Drake, Clifton A. Hipkins.* Greenwich, CT: Greenwich Library, 1982.

Phillips, Marian. *The Palmer Engine Company: An Oral History Interview with Raynal C. Bolling Jr.* Greenwich, CT: Greenwich Library, 1994.

————. *Village Life in Old Greenwich: An Oral History Interview with Daniel Catanzaro.* Greenwich, CT: Greenwich Library, 1989.

Phillips, Marian, and Esther Smith. *From Greenwich to the Olympics: An Oral History Interview with Helen Meany Gravis.* Greenwich, CT: Greenwich Library, 1984.

Smith, Esther H. *Belle Haven Beginnings: An Oral History Interview with John D. Barrett Jr. and Helen Barrett Lynch.* Greenwich, CT: Greenwich Library, 1977.

——. *Byram and the Shoreline: An Oral History Interview with Hugh D. Dougherty.* Greenwich, CT: Greenwich Library, 1977.

WEBSITES

"Great Captain Island Lighthouse History." http://lighthouse.cc/greatcaptain/history.html.

"Grover Cleveland (1885–1889, 1893-1897) The Secret Operation." www.healthmedialab.com/html/president/cleveland.html.

"The Riverside Association of Greenwich, Connecticut." http://riversideassociation.org.

Wikipedia, s.v. "Elias Cornelius Benedict." http://en.wikipedia.org/wiki/USS_Oneida_(1898).

——. "History of Greenwich, Connecticut." http://en.wikipedia.org/wiki/History_of_Greenwich,Connecticut.

ABOUT THE AUTHOR

Karen Jewell writes a weekly column for the *Norwalk Hour* newspaper titled "Water Views," which is currently in its tenth year of publication. Other writing projects have included the "Sailing Scene" column for the *Stamford Times* newspaper; a variety of correspondent articles for TheBoatersTV. com, madmariner.com and diyboatowner. com websites; an article for *Aquarium Fish* magazine; a short fictional novel titled *Beachside Bay*; and, most recently, *A History of the Rowayton Waterfront* and *A Maritime History of the Stamford Waterfront*, both published by The History Press. Having worked along the shoreline in positions as dock master, yacht charter broker, yacht sales broker, sail loft staff and owner of a busy yacht maintenance service, Jewell has had the opportunity to develop strong connections to the waterside community. Living along the Connecticut coastline and enjoying summer vacations on the shores of Maine her entire life, Jewell's passion for all things nautical began at an early age and continues to be the motivation for all her writing endeavors.

Visit us at
www.historypress.net